Forgotten Tales of
Massachusetts

Peter F. Stevens

Charleston · London

THE
History
PRESS

Published by The History Press
Charleston, SC 29403
www.historypress.net

Cover art and internal illustrations by Marshall Hudson.

First published 2009

Manufactured in the United States

ISBN 978.1.59629.621.3

Library of Congress Cataloging-in-Publication Data

Stevens, Peter F.
Forgotten tales of Massachusetts / Peter Stevens.
p. cm.
ISBN 978-1-59629-621-3
1. Massachusetts--History--Anecdotes. 2. Tales--Massachusetts. 3.
Folklore--Massachusetts. I. Title.
F64.6.S747 2009
398.209744--dc22
2008052946

Big Bad John Billington: The Killer Pilgrim

In the woods near Plymouth, a matchlock musket roared. A hunter's quarry crumpled to the forest floor. But the prey was not some wild turkey or other woodland animal. John Newcomen was on the ground, blood streaming from one of his shoulders. Another man disappeared into the forest with his smoking musket. His name was John Billington, and he was soon to become the first man convicted and executed for murder in the Thirteen Colonies.

From the moment in 1620 that a thirty-year-old Londoner named John Billington, who probably came from Lincolnshire, led his wife Elinor and their two young boys onto the *Mayflower* for the impending voyage to the New World, trouble traveled with the other passengers. John Billington, a tough, foulmouthed miscreant, was to bring his own brand of strife to the settlement on the edge of the wilderness.

How Billington wangled his way onto the *Mayflower* is lost in history's murk, but from the onset of the vessel's legendary voyage, Pilgrim leader William Bradford grasped that Billington and his brood did not fit in with most of the other passengers. "They [the Billingtons] were an ill-conditioned lot and unfit for the company," Bradford later wrote. He contemptuously labeled them "one of the profanest families among them [the Pilgrims] and did not know how they had slipped aboard the ship." By the time the Pilgrims, ravaged by scurvy and the other travails of

the perilous Atlantic crossing, first saw the shores of Cape Cod, Billington had made, among his shipboard enemies, a formidable foe in a hard-nosed soldier named Myles Standish.

Aboard the vessel, the Pilgrim men assembled to sign a landmark American document, the Mayflower Compact. Each signer promised to work "for ye generall good of ye Colonie, unto which we promise all due submission and obedience." Men such as William Bradford, William Brewster, John Alden and Myles Standish meant to live by the lofty words of the pact, but the twenty-sixth of the forty-one signers had little intention of obeying anyone. Bradford later branded that twenty-sixth signer—John Billington—"a knave and so will live and die." These words were to ring with chilling, portentous truth.

Billington, as did all the settlers, spent his first months in Plymouth battling for survival against starvation, disease and the harsh New England winter of 1620–21. He and his family endured—to bedevil their neighbors.

As spring's thaw warmed the bodies and souls of the Pilgrims who had survived their first nightmarish winter in the New World, Billington's bullying began again, coupled with a streak of independence he manifested to lead his life as he, not his neighbors, saw fit. But by refusing to honor a summons for military duty, a critical civic obligation for all able-bodied men in a colony worried, with reason or not, that Indians could swoop down upon the settlers' thatched huts at any moment, Billington incensed even neighbors previously willing to overlook his

cursing and his quarreling. The Pilgrims could not let his latest defiance go unpunished.

Billington was sentenced to be bound by his neck and heels, an excruciating punishment designed to make every muscle burn in agony. On April 4, 1621, Standish, undoubtedly eager to settle accounts with the bully, and several other men began binding Billington. Proving that he could mete out punishment to others but could not abide it himself, Billington bellowed for mercy to the magistrates, headed by Governor John Carter. "Humbling himself and craving pardon," Billington convinced his neighbors to untie him; they must have hoped that his close brush with punishment had cowed him into obedience. They might as well have wished that New England's chill winters would grow balmy.

Throughout the 1620s, John Billington ranted and railed against several of his neighbors, adding to his reputation as the black sheep of the village; however, for the settlement, every able-bodied man was an asset. The Pilgrims tolerated their bad neighbor, who was a skilled hunter and a man who could handle himself in a fight against Native Americans if the need arose.

In 1630, even Billington's many detractors must have felt a twinge of pity for him. His son John Jr. died, carried off by gangrene, an often mortal ailment in an era when anti-infectants were few. Billington, in the wake of his son's death, clashed with a new settler named John Newcomen. Either a fearless soul or unaware of Billington's reputation, Newcomen raised the bully's temper to a feverish pitch.

Scholar Gleason L. Archer surmises that a quarrel started over a dispute about hunting, Newcomen perhaps straying into a woodland spot that Billington considered his own.

On a summer day in 1630, Newcomen strode into the woods outside of Plymouth. A musket shot suddenly pealed in the sultry air. A ball tore into Newcomen's shoulder and he crumpled to the ground. The shooter slipped away in a haze of gunpowder smoke.

Pilgrims heard the shot and raced into the woods near the village. They found Newcomen still alive and able to identify his attacker—John Billington. Several men with their muskets in hand scoured the woods for several days. However, Billington eluded them along the Indian paths and thickets that he knew like the proverbial back of his hand.

Unaware that his prey was still breathing, Billington strode back to town after a few days. His neighbors grabbed him, subdued him and hauled him to the lockup, which was perched on a rise above the plantation's cottages and fields. Meanwhile, the vigil over the grievously wounded Newcomen continued. Newcomen finally succumbed to his wound. Billington now faced a murder trial and a fight to save his own life.

The murder trial, the first such proceeding in American history, unfolded inside Plymouth's sturdy wooden meetinghouse. Jurors, with Newcomen's eyewitness account, quickly reached their verdict: guilty "by plain and notorious evidence." Pilgrim Governor William Bradford wrote: "His [Billington's] fact was that he waylaid a young man, one John Newcomen, about a former

quarrel and shot him with a gun whereof he [Newcomen] died." John Billington was sentenced to hang.

Although Billington's guilt was obvious, Bradford and the plantation's other leaders worried that they needed official approval from another legal body to carry out the death sentence. In later years, several historians would contend that Billington himself raised the legal dilemma by challenging his neighbors' authority to hang him.

Bradford turned to John Winthrop, the governor of the Massachusetts Bay Colony. Winthrop, a skilled attorney, replied in late August 1630 and upheld the colonies' first death sentence.

In September 1630, John Billington faced his date with the noose. Despite the trouble he had wreaked upon his neighbors for a decade, the execution could not have been a pleasant event for the Pilgrims. After all, miscreant though he had been, he had been one of the original band of *Mayflower* Pilgrims to arrive on Plymouth's soil and had shouldered his fair share of the labors necessary to carve a settlement on the fringe of a wilderness. For better or worse, John Billington was part of the Pilgrims' adventure. Even Bradford, who had contemptuously dubbed Billington "a knave," admitted that the death sentence was "a matter of great sadness unto them [the Pilgrims]."

The noose snapped tight in the September air. Billington went thrashing into eternity.

Today, memories of John Billington linger in Plymouth. A lake west of town is called Billington's Sea. On the

Mayflower Compact, the hallowed names of Brewster, Mullins, Alden, Bradford and Standish abide for posterity with the scrawl of America's first convicted murderer, John Billington.

"THOU SHALT NOT SUFFER A WITCH TO LIVE": THE STRANGE SAGA OF MARGARET JONES

Jeers erupted from hundreds of throats, rising into the warm June air. Guards led a gaunt woman up a grassy slope to the shadow of a sturdy elm. Her eyes, half shut against the sunlight after weeks in a dark cell, squinted at the noose dangling from one of the elm's limbs.

Then, as she had for weeks, she shrieked her innocence, but a new round of jeers drowned her voice. The Puritans of Boston did not want to hear her pleas for her life. They were on the town common to watch Massachusetts's first witch hang. Her name was Margaret Jones.

Nearly fifty-five years before the witchcraft trials earned infamy for Salem, Margaret Jones was a midwife and a homespun healer in Charlestown, Massachusetts. Her skills in preparing concoctions to ease her neighbors' ills were well known in the little settlement across the Charles River from Boston. John Winthrop noted that among the ingredients she used in her potions and poultices were liquor, aniseed and various herbs, nothing out of the ordinary for seventeenth-century dispensers of "physicke," or homemade medicines.

Little else is known of the woman besides the name of her husband, Thomas Jones. Given her knowledge of potions and childbirth, knowledge not usually acquired in a few short years, Margaret Jones was likely a middle-aged woman, if not older.

Of her alleged misdeeds, an intriguing record remains. Sometime in the spring of 1648, Jones began arguing with several neighbors; although the actual reasons for the friction are uncertain, a contemporary of Jones's later wrote that after the quarrels, "some mischief befell such Neighbors in their Creatures, or the like." Even worse for Jones, according to Winthrop, her medicines were allegedly causing terrible reactions—nausea, deafness, pains—in her patients. He also claimed that a mere touch of the woman's fingers brought on reactions similar to those of her potions. Making matters worse, Jones warned some of her ailing patients that if they stopped taking her "physicke," they would never recover. Her warning may well have been genuine concern on her part; neighbors interpreted her words as a threat.

When her former friends' suspicious glares confronted her, Jones had reason to worry. The sudden spate of accidents and ailments afflicting Charlestown's settlers and even their animals had all the earmarks of witchcraft to seventeenth-century minds. To many locals, a cantankerous woman well versed in the use of plants, potions, liquids and powders that could be turned from medical purposes into satanic arts could seem a sorceress.

John Hale, a twelve-year-old boy who was to become a minister, wrote later in his life that Jones's alarmed neighbors gathered "some things supposed to be bewitched, or have a charm upon them," and burned the items. Jones "came to the fire and seem[ed] concerned," the implication being that a witch was perturbed that her victims were using a "white magic" ritual to combat her "black magic."

What this incident meant fuels all sorts of speculation. If the items burned by Jones's neighbors included objects actually lifted from her home, she had grounds to be concerned; either someone had sneaked into her house to remove the objects or a few neighbors had pushed their way into the house to take them. Fear of witchcraft, a tangible, blood-chilling matter in Old England and New England alike, could easily have driven Puritans to an invasion of the Joneses' house. To have burned "bewitched" or "charmed" objects proved that the people of Charlestown feared Margaret Jones.

Jones's husband, Thomas, was also under suspicion for complicity in his wife's suspected spells. Word that a couple was allegedly practicing witchcraft soon reached across the river to terrify the souls of Boston with imaginings of Satan and his servants on the loose in Massachusetts. On Bendall's Dock, in Cole's Inn, along the shore of the Mill Pond, colonists grew increasingly suspicious of the Joneses.

John Winthrop and Boston's other leaders knew they had to take speedy action to determine if witchcraft was at work. Sometime in the middle of May 1648, the general court of the colony sent men to Charlestown to seize Margaret and

Thomas Jones. The guards loaded the pair into a boat—no bridge as yet connected Charlestown and Boston—and shoved off for the latter town. With each stroke of the oars pulling the couple toward Boston, the husband and wife's fate darkened.

Once the boat ground to a halt on the Boston side of the river, the Joneses were escorted to the local prison, set along a path appropriately named Prison Lane (today Boston's courthouse sits on the site) and shoved into dark, fetid cells to ponder a nightmarish ordeal.

The Joneses' cells, especially Margaret's, were to be a laboratory for the authorities. They intended to subject the Charlestown couple to a common witch-hunting practice known as "watching"; the court's order for the witch test reached the jailers on May 18, 1648.

If Margaret Jones had any idea of what "watching" meant, she knew trouble loomed when her captors walked into her cell with ropes at the ready and hauled her to the center of the room, where a stool or a table was placed. Then the men gruffly offered her a choice: she could sit of her own will on the filthy floor with her legs crossed or be tightly bound in that position. She chose the first option. For the next twenty-four hours she was to sit cross-legged without food or sleep.

Throughout the watching, her cell's door was purposely left ajar or had a small hole cut into the wood. The opening was to let in Jones's "imp," a witch's "familiar." Many seventeenth-century witch hunters believed that a witch's imp came to its mistress or master once every twenty-four

hours, usually under cover of night, after helping carry out a witch's malevolent curses upon his or her victims and before heading out again to help unleash its witch's latest spells. Imps, witch hunters believed, could appear in many guises, from men, women and children to cats, toads and other animals.

Hour after hour passed in Jones's cell, her limbs alternately numb and painful as she sat cross-legged. Her watchers were either inside the cell or just outside the door, waiting for her imp but unsure what infernal manner of specter or beast might appear in the room.

Suddenly a scene straight from the most deeply rooted nightmares of any Puritan reputedly erupted inside the cell of Margaret Jones. Her imp materialized—in the form of a ghostly child. Or so John Winthrop believed. He wrote:

> *In the prison, in the clear day-light, there was seen in her* [Jones's] *arms, she sitting on the floor, and her clothes up, etc., a little child, which ran from her into another room, and the officer following it, it was vanished. The like child was seen in two other places…and one maid that saw it, fell sick upon it, and was cured by the said Margaret.*

The scene is virtually beyond comprehension to today's sensibilities. What rational explanation could account for Winthrop's vivid words, words seemingly more appropriate to Edgar Allan Poe than to a sober-minded leader? Any answer, if it exists at all, lies in the collective

mind of seventeenth-century New Englanders. For so many of the era, belief in devils and witches was literal. Scholars and psychiatrists can offer a dizzying range of explanations—from Puritan paranoia to religious zealotry and mass hysteria—to account for seventeenth-century witch trials, but the fact that Winthrop and many otherwise sane settlers believed that Jones's imp had appeared was a ruinous development for her.

Because witch hunters believed that witches suckled their imps, Jones's jailors stripped her and subjected her body to a search (sometimes women conducted such searches of female witches). The rough hands poking and prodding Jones's flesh sought one sign above all others on her body—a "witch's teat" for feeding the imp. According to Winthrop, the searchers found the sign: "She had an apparent teat in her secret parts as fresh as if it had been newly sucked, and after it had been scanned upon a forced search, that was withered and another began in the opposite side."

To suspicious Puritans, such overwhelming physical signs of Jones's witchcraft were the hard evidence of her crimes. Her day in court, when she was to face the magistrates and a jury, was imminent; for the first time in Boston's annals, a colonist was to stand trial for witchcraft.

Thomas Jones proved luckier than his wife. He apparently passed his captors' watching, never to face trial for sorcery.

Not everyone in the community believed that Jones was a witch. One of her friends, Alice Stratton, steadfastly professed Jones's innocence and visited her in the prison

with a Bible. An onlooker recorded how one day in the cell both women were racked by sobs over the terrible turn Jones's life had taken.

In late May or June 1648, Margaret Jones, likely manacled, was hauled before the general court, which from 1632 to 1659 met in Boston's First Church. She faced not only the evidence of her "imp" and her "witch's teat" but also neighbors' damning testimony of her evil potions and other alleged spells. In many ways, her accusers sounded like people jumping at the chance to rid themselves of a fractious, nonconformist neighbor once and for all.

Sitting in judgment of Jones was a who's who of early Massachusetts's foremost leaders: Thomas Dudley, John Endicott, Richard Bellingham, Richard Saltonstall, Increase Nowell, Simon Bradstreet, William Pynchon, William Hibbins and, of course, John Winthrop. Coincidentally, William Hibbins's wife, Ann, was to be hanged for witchcraft in 1656.

We can picture those men, their faces twitching in anger and even fear as the strange story of Jones's imp, the description of her witch's marks and her neighbors' vivid testimony painted as damning a portrait as would depict any suspected New England witch to follow Jones to the prisoner's bar. Winthrop's journal provides how much the legal deck was stacked against the unfortunate Jones.

The evidence against her was:

> 1. *That she was found to have such a malignant*
> *touch, as many persons (men, women and children)*

whom she stroked or touched with any affection or displeasure, or, etc, were taken with deafness, or vomiting, or other violent pains or sickness.

2. *That she practicing physic, and her medicines being such things as aniseed, liquors, etc., yet had extraordinary effects.*

3. *She would use to tell such as would not make use of her physic, that they would never be healed, and accordingly their diseases and hurts were continued, with relapse against the ordinary course, and beyond the apprehension of all physicians and surgeons.*

4. *Some things she could tell of (as secret speeches) which she had* no ordinary means *to come to the knowledge of.*

Winthrop's remaining commentary about the trial deals in depth with Jones's imp and witch's teat.

Practicing evil physic, foretelling the future, bearing the physical marks of a witch, employing an imp—the so-called evidence left little room for doubt in the minds of most townspeople. Still, Margaret Jones stood before her hard-eyed accusers and vociferously denied all charges of witchcraft, haranguing the court. Her denials were to no avail; the stern judges viewed her cries of innocence as bald-faced lies from a malevolent woman seeking desperately to escape a noose. Winthrop, annoyed that Jones had the gall to plead innocent, wrote: "Her behaviour at her trial was very intemperate, lying notoriously and railing upon the jury and witnesses." Her neighbors found her guilty.

Quickly, the judges imposed the death sentence. Neither pity from her accusers nor a miracle from her God would Jones have. A rope beckoned for the first—but not the last—of Massachusetts's convicted witches. The day of her execution was set for June 15, 1648.

A few hours before Margaret Jones was taken to face the noose, some of her neighbors, including twelve-year-old John Hale, jammed into her cell and begged her to admit her witchcraft to save her immortal soul from the fires of hell. The doomed woman remained steady in her professed innocence despite the badgering of her visitors. She simply listened to the visitors, who had no qualms about stretching her neck but were concerned about dispatching her into the hereafter with the stain of crimes she denied. Hale recorded the sad scene inside the cell:

> She constantly professed herself innocent of that crime [witchcraft]. Then one prayed her to consider if God did not bring this punishment upon her for some other crime; and asked if she had not been guilty of stealing many years ago. She answered she had stolen something; but it was not long since, and she had repented of it, and there was grace enough in Christ to pardon that long ago.

There was not grace enough to move Puritans' hearts to consider the possibility that the woman maintaining her innocence was telling the truth. She was hauled from the prison and hanged somewhere in Boston; although no record of the exact site of the execution was made, two

logical possibilities for the spot are Boston Common and Boston Neck, the latter the site of a public gallows later in the seventeenth century.

When the noose finally "turned off"—a Puritan term for death by hanging—Margaret Jones, many onlookers felt

relieved that Satan had been stymied in their little colony. They were proven wrong. The shadow of alleged witchcraft was to creep across New England and darken the colony through the witchcraft hysteria in Salem in 1692.

A few postscripts to the strange, sad saga of Margaret Jones: Her husband, Thomas, was released from prison and wisely decided to flee the town. He boarded a ship, the *Welcome*, riding anchor off Charlestown; no sooner had Jones set foot on the vessel, wrote Winthrop, than it began to founder. The *Welcome*'s alarmed captain, well aware that Jones's wife had perished as a convicted witch, pleaded for authorities to remove Thomas Jones from the ship. Winthrop and other leaders were happy to oblige the panic-stricken shipmaster. Once Jones was hauled from the *Welcome*, he was heard of no more.

At least one person continued to profess Margaret Jones's innocence after the hanging. Alice Stratton charged that her friend had "died wrongfully" and that Jones's blood was upon the magistrates' hands. Winthrop and company, a thin-skinned lot in the face of criticism, cast baleful eyes at Stratton and were soon hard at work seeking signs that she was a witch. The search yielded no damning evidence that the court could pin on Stratton. Fortunately, she escaped the fate of her luckless friend.

Margaret Jones's brief but tragic foray on colonial America's stage had ended, but her legacy, though not her name, endured each time a New Englander convicted of witchcraft stood hopelessly with a noose fastened around his or her neck. Of Jones's guilt, Winthrop never

evinced the slightest doubt. In John Hale's thoughts, however, a sense of uncertainty that she was a witch lingered, the grown Hale wondering if what he had seen at twelve had been as black and white as Winthrop believed. Unlike Winthrop, whose journal depicted the distraught Jones as the seeming embodiment of a witch, Hale recorded Jones's unwavering assertion that "as for witchcraft she was wholly free from it—and so said unto her death.'"

As would many convicted witches who followed her to a noose.

A TASTE OF HEAVEN:
DR. BAKER'S CHOCOLATE FACTORY

Something was in the air. People on their daily rounds along the roads of Dorchester and Milton Village, Massachusetts, turned their noses toward the Neponset River and sniffed the spring breeze. "Chocolate!" the passersby likely murmured, eyes aglow in delight, mouths watering.

The year was 1765. The heavenly scent drifted from a sawmill on the banks of the river, within eyeshot of Boston. Inside the mill an Irishman watched two millstones grinding fragrant cocoa and sounding a call to a culinary revolution that was to capture the palate of America.

In the fall of 1764, a shabbily dressed man named John Hannon arrived in Milton Village without a shilling in his pocket. He was looking for work, for a chance to make a life for himself.

Aside from his vagabond appearance, something else about him would have troubled the industrious local Yankees who cast wary glances at the stranger. Whenever the man opened his mouth, his words spilled out in an Irish brogue. To colonists whose hearts still beat with the anti-Irish prejudices of their Puritan ancestors, an Irishman in their midst was reason for concern.

Hannon had something to offer his new neighbors. The Irishman knew how to make chocolate, the sweet nectar that had become a choice beverage to colonists but had to be imported and laboriously ground with mortar and pestle or cumbersome "hand mills."

One of the locals, Dr. James Baker, met Hannon somewhere in Milton, chatted with him and realized that if the stranger really knew how to start up a chocolate mill, profit beckoned anyone willing to gamble on bankrolling him. Baker, a Harvard graduate who had practiced medicine and had run a Dorchester store, was a restless sort, looking for his golden opportunity. He decided to take a chance on the man with the brogue.

Hannon did not need a large space to set up shop, but he did need water power to grind large loads of cocoa beans. In the spring of 1765, Baker found his partner an ideal site, a sawmill perched alongside the Neponset River. Hannon soon was ready to begin grinding beans between two enormous round millstones.

Spun by the Neponset's flow, set to one-third the speed used to grind corn, the top stone lurched into motion. Then Hannon poured cocoa beans into a hole cut through the

center of the top stone. The bottom stone started whirling, and the motion of both stones pulverized the beans into a dense, syrupy liquid. The hot liquid was collected in a kettle and poured into molds to cool and form chocolate cakes, which were actually more like bricks. John Hannon was no lying braggart; he had delivered the goods. In the first grating strains of the two millstones, America's first bonafide chocolate factory and a financial dynasty had been born on the banks of the Neponset. The dynasty, however, would not bear the name Hannon.

Hannon and Baker were not the first Americans to make chocolate, for in Providence, Rhode Island, in 1752, Obadiah Brown had built a water-powered chocolate mill and had churned out four hundred pounds of the stuff for Newport merchants. Still, Brown's venture had been a mere drop in the kettle and, unlike the future course of Baker and Hannon's plant, had been short-lived, which is the reason that the Baker plant stood as America's first real chocolate concern. (Most texts on the matter flatly call Baker's plant the first.) Hannon and Baker were in the chocolate business for the long haul.

With the exception of the lucky passersby who caught a whiff of chocolate from the sawmill, Americans had no idea that a cure for chocolate lovers sore-armed from grinding cocoa beans with mortar and pestle of hand mills was in the offing. The Harvard man and the Irish immigrant were to bring smiles to the faces of the Thirteen Colonies' "chocoholics."

Soon after the first chocolate droplets cooled, Baker and Hannon were selling their hard cakes to sweet-toothed

neighbors. The exact nature of the partnership between the Yankee and the Irish immigrant is hard to define, but at the beginning of their venture, Hannon was the "hands-on" person and Baker the financier. The pair's first chocolate was fittingly sold under Hannon's name, advertised in handbills to lure chocolate buffs to sample the partners' aromatic cakes, which customers would scrape and boil with water to make cups of cocoa.

The locals obliged Hannon and Baker in increasing numbers. To meet the rising demand from patrons, the duo moved their operation in 1768 to a fulling (cloth) mill on the Dorchester side of the Neponset, renting the space from Baker's brother-in-law, Edward Preston. In coming years Baker came to regret bringing Preston within sight of the chocolate plant, for Preston was to show that he knew a good thing when he saw it—and was ready to capitalize on it.

Baker, who had first recognized that good thing, opened a second chocolate factory in 1792. It is unclear whether a rift had developed between the partners or whether they simply expanded the operation to meet customers' frenzied thirst for hot chocolate. What was certain was that Baker had obviously learned much of the Irishman's craft, for the new mill ground at least 895 pounds of chocolate in 1773.

Whatever Baker's reasons for having opened the second plant, he had made a lucky decision. Flames engulfed Hannon's factory in 1775. The loss of the entire operation had been precluded by the establishment of Baker's plant.

Hannon rented space in a nearby snuff mill and was soon back in production. Presumably, he guarded his cakes

from any tobacco residue wafting into his plant from the adjacent snuff maker, and his wares continued to sell.

Flames of another sort, those of the Revolutionary War, soon blazed near the mills. While musketry and cannonades rose above nearby Boston, Hannon and Baker fought to keep their business afloat. Dependent upon West Indies cocoa beans, the chocolate makers ran shipments of beans through the gauntlet of British warships prowling the Atlantic coastline. Luckily for the two entrepreneurs, the war shifted to other theatres after General Washington's cannon on Dorchester Heights, and undoubtedly within view of the two anxious chocolate makers, sent Lord William Howe, his redcoats and the Royal Navy scampering forever from Boston. Hannon and Baker could go back to business without worrying about "lobsterbacks" ransacking or torching the chocolate mills.

The British were gone locally, but Hannon and Baker still had to run beans from the Caribbean. In 1779, Hannon reportedly boarded a ship bound for the chocolate markets of the West Indies. As the vessel sailed beyond the New England coast, Baker's partner took his last look at the region. Two rumors about John Hannon's fate arose after he failed to return to America. The more plausible contended that his ship sank in the Atlantic and took the Irishman to the bottom.

The second conjecture claimed that Hannon boarded his ship and safely reached the West Indies but had no intention of returning to America. Allegedly chafing from a bad marriage to a Boston woman named Elizabeth

Doe and perhaps yearning for his "ould sod," Hannon may have sailed back to Ireland. One fact is certain: the Irish immigrant who, with Baker, had begun an industry in America disappeared from history. His name was forgotten, his legacy consumed by another's name—Baker's Chocolate.

Baffled no doubt by Hannon's disappearance but with a business to run, Baker could not dwell on his partner's fate. Hannon's wife soon concerned Baker more than the missing Irishman, for she intended to hang onto her husband's share of the chocolate business. Baker had other ideas.

When Hannon departed Boston, he had left his mill in the capable hands of his apprentice, Nathaniel Blake. But Blake and Elizabeth Hannon spent more time arguing about the operation of the plant than making chocolate. Blake soon quit his post and quickly found a new job—with James Baker.

By 1780, Baker had control of his ex-partner's interest. How Baker finally got his hands on the Hannon plant is open to speculation, with one figuring that the Irishman's "widow," unable to replace Blake, was compelled to sell her share on Baker's terms.

Baker, choosing to consolidate the entire business under one roof, opened a revamped factory at Edward Preston's new mill, on the site of the mill that had burned in 1775. For the next eight years, load after load of cocoa beans was roasted in kettles, mashed into steamy liquid between the weighty millstones and poured into molds, the aroma

swirling above the plant. With each brick of chocolate from the spinning stones, Hannon's name faded farther into oblivion. The first name in American chocolate was Baker.

In 1791, Dr. Baker packed up his operation and moved again to an old paper mill. The reason for the move was probably strained relations between Baker and Preston, who was preparing to open his own chocolate plant and go head to head with his brother-in-law and former tenant for a piece of the chocolate market. Over the years, Preston had obviously studied Baker's kettles, stones, molds—and profits. Chances were that the two men were never inclined to chat amicably over a steaming cup of cocoa.

In 1804, nearly four decades after meeting a down-on-his-luck Irishman named John Hannon, James Baker stepped down from his perch as America's chocolate king and bestowed the "title" upon his son Edmund. A new era, one perhaps inconceivable to Dr. Baker and Hannon even in their grandest hopes for their sweet product, was about to dawn for the young nation's chocolate lovers.

Edmund Baker, teeming with plans to put his stamp upon his father's enterprise, wanted to build a modern mill on the Dorchester side of the Neponset. Meanwhile, he took care of the present by temporarily moving the plant back to the old sawmill in Milton where his father and Hamilton had ground their first beans.

The younger Baker forever closed the doors of the venerable old mill in 1806 and started roasting, grinding, cooling and distributing chocolate in his plant. For 150 years, chocolate was to flow from the site. Edmund Baker

also showed general business savvy, opening a gristmill and a cloth mill alongside the chocolate factory and expanding the family's little empire on the Neponset. Small wonder that the Neponset was dubbed "the river of American business," a river where Baker ruled.

Baker's Chocolate began turning up on store shelves from the East Coast to the western outposts of America's ever-swelling borders. Suddenly though, disaster encroached upon the Baker chocolate mill: the War of 1812. America's second conflict against Great Britain cut off Baker's supply of cocoa beans and forced Baker to bring his factory to a shutdown. With the plant's huge millstones still and silent, its kettles and molds empty, Baker could take solace in his foresight in having opened his gristmill, for grain was in demand, and his cloth mill, which he successfully enlarged despite the war. Had he tied up all his family's assets in chocolate—and who could have blamed him if he had?—the saga of Baker's Chocolate might have ended between 1812 and 1814.

That the brown nectar would stream again from his stones was an ironclad reality to Edmund Baker. Despite the lack of beans, he tore down his chocolate mill and built an impressive granite edifice standing three stories, a fitting home, he believed, for the future capital of American chocolate. With the war's end in 1814, carloads of Baker's Chocolate again rumbled in all directions to tickle the taste buds of Americans.

Edmund Baker, having gotten the chocolate business back on its feet and pointed it toward the future, selected

his son Walter as the man to complete his dream of putting the plant's chocolate in every corner of the nation. The son endeavored to do just that.

Walter Baker inherited a business gaining national stature but faced problems his grandfather could scarcely have envisioned at Preston's mill in 1765. Straining to satiate Americans' bottomless appetite for chocolate, Baker increased his workforce. In a sign of the changing times in America, he hired not only men but also women. Mary and Christina Shields, hired in 1834, were the first in petticoats to draw wages from a Baker. The two women worked out well, for by 1846 Baker's payroll was composed of two workmen, two male apprentices and *seven women*. As was true of most of the era's bosses, Baker paid women less than men.

His employees certainly earned their wages. Conditions inside the plant that smelled like heaven but must have seemed like hell as the orders piled up were certainly grueling enough to make some workers loathe the very sight and scent of chocolate. Americans far removed from the heat and noise of the chocolate mill were heedless of the labors required to bring the treat to local stores. Chocolate lovers knew only that they could not get enough of their sweet vice.

According to a Milton, Massachusetts historian, one fellow who learned firsthand of his countrymen's passion for cocoa was a tall, craggy-faced man with a shock of unruly black hair. He stocked shelves with Baker's best in New Salem, Illinois, in 1833—the clerk's name was Abraham Lincoln.

Americans' readiness to splurge hard-earned cash on chocolate sparked full-fledged competition for the Bakers in the 1830s. By 1835, the Preston mill was churning out 750 pounds of chocolate a day. Edward Preston and his family had learned the tricks of the trade well.

Baker's industrial backyard grew more crowded in 1842. A third chocolate mill, Webb & Twombly, rose along the Neponset. Although the new plant's owners fathomed little about the business—other than the fact that the Bakers and the Prestons were turning profits—the latest arrivals had lured one of Preston's men to pit the new factory against the others. Soon after the opening of Webb & Twombly, the smell of chocolate permeating the banks of the river led locals to name the area "Chocolate Village."

"Chocolate Wars" was an apt term for the way the three factories sent out one wagonload after another of their delectable products from Lower Mills, as the collection of factories was known, to the cupboards of American homes. The grinding of each plant's millstones being constant, the chocolate trade was one in which volume meant profit; in the 1840s and 1850s, beans went for ten cents a pound, while Baker charged sixteen cents a pound for his best brand of chocolate and twenty cents for his top cocoa.

Volume and competition were not the only concerns of Baker and the other chocolate makers. Every summer the plants' stones ground to a halt. Effective refrigeration for chocolate was nonexistent; not until 1868 and the advent of "cold technology" could the "generals" of the Chocolate Wars wage summer campaigns.

Walter Baker's last campaign in the business came long before refrigeration turned chocolate into a year-round operation. He died in 1852, and with his passing ended the Baker dynasty. For eighty-seven years the family had ruled its chocolate fiefdom on the banks of the Neponset and had persevered in the face of war, embargo, fire and rivals ruthlessly striving to topple the family that had founded America's first permanent chocolate factory. The leadership of Baker's Chocolate passed to men with other names.

The company continued to make chocolate along the Neponset until 1965. In that year, two centuries after Dr. Baker and Hannon had filled their first molds, Baker's Chocolate shut its doors along the Neponset, a decision made by the outfit's parent corporation, General Foods, which had purchased the world-renowned chocolate maker in 1927. Baker's Chocolate's new home was Dover, Delaware.

More than two hundred years after the first rich brown droplets oozed from the rims of Baker and Hannon's grinding stones, America's love affair with chocolate waxes unabashed, testimony to the good taste of Dr. Baker and James Hannon.

THE KING OF CHRISTMAS CARDS: LOUIS PRANG

In a Roxbury, Massachusetts office in 1874, a young woman waited. Across from her a bearded, fiftyish-year-old man stared at her card-size watercolor, his craggy face

furrowed with thought. Her drawing, of a red rosebud with a few leaves and a graceful stem, was simply rendered, but something in the man stirred at the play of the rosebud against a black background. The image had possibilities for a product he had been hatching in his mind.

A short while later, as the young artist, Mrs. O.E. Whitney, left his office, she had reason to smile. Louis Prang, an internationally acclaimed printer of lithographs and business cards, had bought *her* watercolor. Although she could not have known at the time, her little painting was to become a hot property. Prang intended to turn her work into a landmark creation: the lithographer was to feature Whitney's design and other artists' work on America's first commercially successful Christmas cards.

The king of Christmas cards was born in 1824 in the town of Breslau, in Prussian Silesia, and grew into an unhealthy youth whose education suffered because of his frequent absences from school. His father owned a calico-printing business, and he took in his frail son as an apprentice when the boy was thirteen. Young Prang, taking to the trade, was introduced to the intricacies of print design, wood and metal engraving, dyes and color schemes, all lessons he was to carry for the rest of his life. His health also improved.

When Prang turned eighteen in 1842, he left Breslau, seeking to enhance his knowledge of his craft with other mentors and straining to throw himself into the world beyond his hometown with the independence of eighteen-year-olds of all eras. He worked for a time at his brother-in-law's paper mill in Westphalia. He also avoided a stint in the

army; his family, concerned at how the formerly frail young man might hold up under the strains of military draft and barracks life, apparently knew someone able to pull official strings to keep him out of the service.

No strings could keep Prang in Westphalia, as he had a desire to hit the road again. After leaving his brother-in-law's employ, Prang worked for printers and dye shops in Austria-Hungary, Switzerland, France and Great Britain. He was not merely accumulating knowledge in his trade but also, if his later life was any indication, commencing a lifelong love affair with art, a passion inspired by European masters' paintings and prints he viewed in public galleries and museums.

In 1848, the meandering trail of the twenty-four-year-old Prang led him back to Prussia, where the flames of revolution against Prussia's nobles, the Junkers, nearly engulfed him. His affinity for some of the radicals' democratic ideals was mainly confined to thought rather than deed, but by the end of the turbulent year, when King Frederick William IV and his Prussian army had reinstituted the Junkers' order, Prang had fled to Switzerland with his eyes on a new land, a land whose revolution had succeeded.

On April 5, 1850, twenty-six-year-old Louis Prang set foot in New York City, bracing for the biggest adventure or nightmare of his young life. He was better off than countless other immigrants to America's shores, for he could read and write and, most important, had a trade.

He did not stay long in New York, where the city's squalid tenements housed countless immigrants who

bitterly learned that, for most of them, America was not the land of opportunity but the land of despair. Prang soon headed to Boston. While the former bastion of Puritanism was hardly an oasis of tolerance for immigrants, Prang found that his knowledge of printing was a strong selling card to local businesses. He worked for an architect and designed engravings for books and illustrations for Frank Leslie, art director of *Gleason's Pictorial* and future publisher of a widely popular periodical, *Frank Leslie's Illustrated Magazine*. Except for a brief foray into the leather goods trade, Prang came to realize that engraving, a craft he enjoyed and one at which his proficiency was rising, was his likeliest path to the American dream. In a new land where a foreign accent garnered cold stares or worse, where most immigrants were limited to backbreaking manual labor for miserable wages, Prang recognized that he was one foreigner lucky enough to practice his chosen field.

In 1851, he became lucky in another realm: love. Prang married Rosa Gerber, a Swiss woman who remained his wife and companion for nearly fifty years. Soon the printer had another Prang to work for—a daughter.

The Silesian immigrant, seeking to provide a steady income and a stable life for his new family, wanted far more than to hire out his talents to local printers and engravers. He craved to run his own business, to be his own boss, not an easy prospect for any immigrant.

He dug into his savings in 1856 and started a lithography business. It was a highly competitive field in which

entrepreneurs scrambled to turn a dollar selling business cards, invitations and the like and to place their artwork in magazines free to pick and choose from talented engravers throughout America. Initially in partnership with a man named Mayer, thirty-two-year-old Prang poured into Prang & Mayer all that he had learned of printing, colors and engraving.

At his Boston plant, Prang placed designs coated with greasy material on flat stones or metal plates and then carefully added water and ink to the design. The greased images soaked up the ink and repelled the water. The results were lithographic prints, which in the hands of a shoddy craftsman could emerge as a blotted mess. Inferior workmanship did not slip past the sharp eye of the meticulous Silesian.

By 1860 his plant, which had become Prang & Company, was successfully running off business cards, formal announcements and other moneymaking staples of the printer's trade in and around Boston. However, Prang was not content to remain just another printer straining to keep his ledgers in the black. Always scouting for avenues to put his lithographs on the national "map," which usually meant magazines and books, he found his way to acclaim beyond Boston—with a *map*. Shortly after Confederate batteries bombarded Fort Sumter into submission on April 12, 1861, and unleashed the Civil War, Prang printed a map of the surrendered fort and Charleston Harbor; with Northerners clamoring for every possible scrap of information about the portentous event,

Prang's lithographic map sold well. He was onto a vein of commercial gold, which he mined for the rest of the war, printing battlefield maps and small cards bearing the images of Union army leaders. Prang's business sense was shrewd enough to set the head of any captain of commerce nodding in admiration.

As the war raged into 1864, Prang took his wife and child on a trip to Europe. The lithographer, gazing once again at the glorious artwork all around him, was developing a new business idea. His concept, one certain to win snickers from well-heeled sorts in costly brownstones from Boston to Philadelphia, was to bring prints of masters' oil paintings into the homes of average Americans.

Shortly after his return to Boston, Prang began experimenting with ways to put his concept into inked reality at his busy plant. By 1866, he had developed a technique he called chromo, which produced lithographic copies of great paintings. Many businessmen believed that Prang's venture was doomed to fail; they warned that his prices were too steep at six dollars a copy.

The naysayers were wrong. Buyers intrigued by the notion of owning a reproduction of a masterpiece snapped up Prang's chromos from the shelves of stationery stores. Largely because of the chromos' success, he relocated in 1867 from Boston to a new state-of-the-art factory in nearby Roxbury, where he and his staff strove to meet the rising demand for Prang's skillfully rendered chromos, which included the masterful seascapes of Winslow Homer.

Prang not only had begun bringing great art to average Americans but also had brought a splash of color to the usual black-and-white world of the nation's printers. The same use of color upon business cards helped steer Prang toward a Christmas novelty that captured the fancy of millions.

Business cards were on Prang's mind and in his hand as he passed them to potential clients at the Vienna Exposition of 1873. His eye-catching cards featured colorful floral designs that adorned backgrounds of various hues, the moniker of Prang's company etched in the card's center. The cards won not only new customers for Prang but also the scrutiny of Mrs. Arthur Ackermann, the wife of Prang's British agent in London. She envisioned Prang's products as something more than business cards: she saw Christmas cards.

Christmas cards had turned up during the 1840s in British stationery shops but had not fared well initially. The seasonal trifles, derived from religious cards exchanged on or near Catholic holy days, had begun tugging at some English hearts and purse strings in the 1860s. Mrs. Ackermann, who had signed with a flourish London style– Christmas cards destined for friends, perhaps including Prang himself, helped convince the Boston lithographer to design Christmas cards for sale in Great Britain.

Enamored with the idea, Prang wasted little time. His first line of Christmas cards, bearing his trademark of vivid colors, was on British shelves for the holiday season of 1874. The small novelties from the Roxbury plant proved a hot seller throughout the United Kingdom, where customers

gladly dropped a shilling or two for the delightful cards of the master lithographer, a fact that must have dampened holiday cheer for a few London card makers.

In Prang's office on the other side of the Atlantic, the sales figures from London caught the printer's attention. The time was right, he sensed, to introduce Christmas cards to America. One of those cards was to be Mrs. Whitney's rosebud.

If Prang knew America's history, he grasped the irony of introducing Christmas cards to a region whose first white settlers, the Puritans, had abhorred any celebration of the Yuletide, a holiday they associated with "Papist" rituals. Now, on turf where the Puritans had trod, Prang & Company was fashioning a celebration of Christmas made in the firm's print shop.

Prang's impending sale of America's first Christmas cards was not his first attempt to package Christmas novelties to New Englanders, for in 1868 he had offered illuminated chromos with Christmas themes intended to grace customers' walls. He had also offered small Yuletide greeting cards for placement in albums. But the concept of mass producing holiday cards that people could offer one another as heartfelt tokens of holiday cheer was an idea whose prospects of success—no matter what Prang's instincts—were as murky as some of the inks splashed across his flat lithographic stones. Success in Great Britain did not guarantee a similar triumph in America.

Not even Prang's most optimistic hopes for America's first Christmas cards could have exceeded buyers' reactions

during the preholiday weeks of 1875. One glance at the cheery cards, crafted with the same chromolithography techniques that had won popularity for Prang & Company's reproduction of oil paintings, was sufficient to make many Americans joyfully purchase Prang's cards and hand their loved ones the novel holiday notions.

Knowing that he had a hit on his hands as he counted the receipts of Christmas past, Prang swung into production for Christmases future. From his factory over the next few years poured a delightful array of Christmas cards. Buyers reveled at the choices of Yuletide cards, brimming with vibrant floral images such as Whitney's, pictures of birds and butterflies, Nativity scenes, angels of all shapes and sizes, picturesque winterscapes, elves and, of course, Santa Claus. Prang himself, with his whiskers and bushy eyebrows, could have served as his artists' model of "Old St. Nick," whose rosy face was helping turn Christmas into a merry holiday indeed for Prang & Company.

The holiday wishes inscribed on some of the cards were words from such poetic titans as Longfellow, Whittier and Bryant. Many cards featured the written musings of Celia Thaxter and Emily Shaw Forman, both of whom were part of Prang's Yuletide team.

Production of Christmas cards soon soared to upward of five million a year. Small versions roughly the size of playing cards and printed on only one side sold for a dime apiece; people unconcerned about pennies parted with a dollar for larger cards embossed with elaborate designs and festive ribbons, the steep price tag the result of lithographic

costs in which the use of myriad inks and stones produced a beautiful card but pushed along chromo costs to customers. Few apparently complained about the prices, for as the ever-rising production of the cards proved, Americans of the 1870s and 1880s were willing to pay their dimes and dollars for Prang & Company's quality product. Thanks to his cards' booming sales, Prang was indeed finding Christmases merry and his New Years happy.

America's budding market for Christmas cards kept Prang on the prowl for new themes for his holiday moneymakers. He ran contests in which artists of the early 1880s designed potential Christmas cards for Prang & Company. The competition was stiff, and for anyone—in 1880 or now—viewing Prang's cards as crass commercialization of a religious holiday, one look at the talent bursting from many of the contestants' entries should have been proof that America's early Christmas cards were a union of profit and art. Such prizewinning entries as Lizabeth Humphrey's 1882 drawing of a benevolent Santa gazing down at a child pensively awaiting the jolly old elf were more than money in the bank for Prang—the entries were the work of skilled artists. Prang, a lover of fine drawing and clever brushwork, proved his affinity for contestants' work by paying generous awards for prizewinning submissions, testimony to his own Christmas spirit.

Prang showed little affinity for card themes smacking of the avant-garde, but he allowed his production people latitude in cards' configurations, with those cut in the shapes

of diamonds and stars making their way into his holiday stock. A bit of glitz from his designers sometimes passed his muster, as evidenced by a Christmas card cut into the shape of a star and gleaming with tinsel.

As his card sales continued to soar, so did Prang's unflagging zeal to bring a love of art into the mainstream of American life. From 1882 to 1908, under the imprint of the Prang Educational Company, Prang's instructional books on drawing, painting and art appreciation enriched classrooms throughout the nation. *Teacher's Manual for Prang's Shorter Course in Form Study and Drawing*, *A Course in Water Color*, *Art Education for High Schools*—those works and other projects weaned some future American artists. Perhaps more important, Prang's primers infused a lifelong love of art in many students who were never to draw and paint with the skills of more artistically apt pupils but who were to gain an understanding of art previously reserved for the offspring of America's well-to-do. "Art for the masses" could have been Prang's motto, proving that at least one successful American capitalist understood that art should belong to blue bloods and the poor alike.

In the early 1880s, the man who had brought a new Christmas custom to Americans and was in the midst of getting the Prang Educational Company off the ground floor hired a Syracuse, New York woman to help with his campaign to bring art to America's students. His hiring of Mary Amelia Dana Hicks was to prove a pivotal event in both the business and the personal life of Louis Prang.

Hicks, a widow in her mid-forties, was the sort of woman who sent hard-boiled male chauvinists of the nineteenth century into fits of rage and teeth gnashing. After the death of her husband in 1858, she taught art to support herself and her daughter and rose to become art director of Syracuse's public school system. A mix of art lover, educator and administrator, she soon showed that her business acumen and her knowledge of art were second to none of the boys at the Prang Educational Company.

Hicks was named director of Prang's art classes in 1884 and, as the 1880s and 1890s unfolded, was a strong force in production of virtually every Prang art manual, her editorial eye as sharp as that of any male peer. There was little doubt that Mary Hicks was one of the company's most valuable players, a woman whose abilities captured the notice of her bewhiskered boss.

By 1890, the efforts of Hicks and others involved with Prang's art manuals had taken center stage at the company, which had opened offices in New York and Chicago. Prang's Christmas cards had been shoved in the background not only by the firm's art books but also, according to Prang, by cheap cards produced in France, Great Britain and his birthplace, Germany. Waning American interest in Christmas cards prompted Prang to shut down his Yuletide operation in 1890. He was wise to do so. The sale of Christmas cards in America virtually died for the next decade or so. A wistful twinge or two must have pulled at the heart of the sixty-six-year-old printer whenever he recalled his first Christmas cards, painstakingly crafted with

stones and ink, and the delight these Yuletide scenes had brought to countless Americans of all ages.

Eight years after the demise of Prang's cards, he suffered a far more grievous loss: his wife, Rosa, died on June 2, 1898. The following year, Louis Prang retired. Retirement was not to be a slow slide into utter inactivity for Prang. In what might have seemed a miracle to the seventy-six-year-old widower, he and sixty-three-year-old Mary Amelia Hicks found themselves spending more and more time in each other's company. They exchanged vows on April 15, 1900, and over the next ten years the former lithographer and the ex–art teacher traveled far and wide, bound by their companionship and their passion for art.

Louis Prang died in Los Angles on June 14, 1909. His widow, Mary, went on to earn an arts degree from Radcliffe in 1916, and in 1921, at the age of eighty-five, she earned a master's degree from Harvard. She had become a great philanthropist of the American art scene, her role one of which the man who had awarded generous stipends to Christmas card artists would have approved. Mary Hicks Prang died in Melrose, Massachusetts, on November 7, 1927, having kept the name of Prang a proud and cherished one in the arts.

Few remember Louis Prang today, but every time Americans walk into a store during the holiday season, select boxes of Christmas cards from a shelf and smile, the shoppers experience the same Yuletide warmth that the Americans of 1875 felt.

To a modern Scrooge, Christmas cards are overpriced, commercialized, saccharine sentiment. To holiday revelers, the cards are—and will always be, no doubt—a heartwarming tradition. Both opinions aside, Americans continue to buy Christmas cards. Today's greeting card giants know that fact well, for in 1875 the ink-blotted stones of Louis Prang told the nation so.

THE HARVARD HOODLUMS

Here's a saga that could turn Harvard grads crimson. It is a classic case of two of the best and the brightest failing not only as students, but citizens as well.

In the early 1640s, two young men stowed their clothes and books in Harvard's sole dormitory and began studies alongside the colony's other aspiring scholars. No one questioned the suitability of James Ward and Thomas Weld to assume their places among the newest crop of Harvard men. Ward, a promising, reserved sort, hailed from the family of Nathaniel Ward, one of the colony's preeminent intellectuals, who had codified his fellow colonists' rights into the landmark Body of Liberties.

Weld, a "lively" yet sometimes surly young man, also carried a prime Puritan pedigree. He was the son and namesake of Reverend Thomas Weld, a Massachusetts Bay mover and shaker who ruled the pulpit of one of Boston's meetinghouses in Roxbury and served as an overseer of Harvard's regents. With such connections and

the confidence that his family name afforded him amid students and teachers alike, young Weld soon carved out a reputation as Harvard's leading hell-raiser.

That the high-spirited Weld struck up a fast friendship with the quiet Ward provided a classic example of a

gregarious undergrad taking a less sophisticated classmate in tow. Few at Harvard, however, guessed at the real glue binding the friendship of the Puritan "odd couple."

In the early spring of 1644, stunning news spread from the muddy paths of Boston and across the Charles River to the college: someone had broken into two Boston homes in the dead of night and had escaped with several rings and fifteen pounds sterling, a sizable chunk of colonial change.

No local in his or her right mind envisioned that a break in the case would come from Harvard Yard. A strange story soon wafted through Harvard's dormitory and to one of the college's officials. The administrator quickly contacted Governor John Winthrop.

To Winthrop's shock, the rumor alleged that two Harvard students were spending large sums on "frivolous pastimes": strong drink and young women. The pair was none other than James Ward and Thomas Weld, sons of Puritan privilege.

Immediately Winthrop ordered a search of the students' quarters. The constables hit pay dirt—several pounds sterling and the missing rings. After hearing the sorry pleas of the Harvard hoodlums, the magistrates decided that no jury would be impaneled, but opined that the duo should be "severely punished." Neither a painful lash nor a humiliating stint in the stocks awaited the "poor little rich boys." Winthrop and the court turned over America's first collegiate criminals to their parents, any punishment remaining a family matter.

Had Yale existed in 1644 and had some irate Bostonian leaked the "hush-hush" story of the Harvard hoodlums to the

Yalies, for every generation to follow, the New Haven crowd could have turned Harvard faces crimson with taunts of two underhanded undergrads hailing from Harvard Yard.

"ETERNAL HAPPINESS":
AMERICA'S FIRST BOARD GAME

All eyes peered at the eight-sided wooden top spinning dizzily across a gaming board, for the printed number that would face upward as soon as the whirling "teetotum" stopped would decide the fate of the players. If the wrong digit turned up, a stint in the pillory, the stocks or a cell loomed for the misfortunate gamester.

In 1843, the scene played out not in waterfront gambling dens throughout New England, but in the parlors of the middle and upper classes. The "game of chance" featured neither wagered wads of cash nor "demon" dice. From Rhode Island to Maine and everywhere between, parents and children alike were gathering around parlor tables and, in the flickering glow cast by oil lamps or candles, were spinning the teetotum and moving wooden pegs across the brilliantly colored spaces and the artwork of America's first original board game—Eternal Happiness. No mere fad, the pastime would launch a worldwide industry and earn Salem, Massachusetts, status as the "Cradle of the American Board Game."

In the early 1840s, Anne W. Abbot, the thirtyish daughter of a Beverly, Massachusetts minister, strolled

into a gabled, wood-frame building in the neighboring town of Salem. Standing at 230–232 Essex Street, in the seaport's commercial hub, the structure housed the clattering printing presses of W. & S.B. Ives Company. The woman walked into William Ives's cluttered office with a business proposal.

The fifty-year-old printer, balding and bespectacled, had proven himself the quintessential Yankee businessman, shrewd, hardworking and able to recognize a golden opportunity when he heard one. And he had heard one in 1840 from the prim and proper minister's daughter: she had invented a children's card game entitled Dr. Busby and had convinced Ives to print and market it. The vividly hued amusement offering children and their parents a fast-paced, free-wheeling parlor pastime netted both creator and inventor a tidy profit.

Abbot now showed Ives her new creation, Eternal Happiness, which she pitched as an "instructive, moral and entertaining amusement." Ives was looking at America's first bonafide board game, and the notion intrigued him. Anne Abbot had devised the idea, but Ives—if he decided to cut a deal with her—would bear all the financial burdens to bankroll, print and market the game. The risks notwithstanding, the Yankee merchant gambled on Anne Abbot, the woman who had "introduced" him to Dr. Busby.

At first glance, the serious visage of William Ives, a man who literally spent his working life elbow deep in printer's ink, hardly cast him as a fun and games sort. Abbot, however, had chosen her backer sagely. Born in Salem on

February 15, 1794, the eldest son of sea captain William Ives and Mary Bradshaw Ives, the mariner's namesake, his three brothers and his sister grew up in a proper New England household in which the virtues of hard work, devotion to family and the tenets of the Congregationalist faith governed the children's lives. For the right-thinking parents of Ives's Salem, teeming in the opening decades of the nineteenth century with merchant ships laden with the wealth of the Orient, Africa and Europe—spices, gems, silks, pepper, opium—and with "tars" prowling the city's waterfront for liquor and women after months at sea, keeping children on the "straight and narrow" in a town where the exotic and the status quo walked the streets posed a formidable task.

Captain Ives and his wife did not need to worry about their eldest child. The sea holding little allure to him as a career, William Ives fell in love with books and newspapers. He got his first whiff of newsprint when he served as an apprentice to Thomas C. Cushing at the *Salem Gazette*. After learning everything from setting type to writing good leads for articles, Ives branched out to open his own newspaper, the *Observer* (later the *Salem Observer*), on January 2, 1823.

In partnership with his twenty-two-year-old brother, Stephen, Ives formed the W. & S.B. Ives Company; however, Stephen quit the business in 1838. Realizing that a newspaper's costs could ruin a family man, Ives not only printed the *Observer* but also turned W. & S.B. Ives into a bookseller, a printer, a binder and a publisher.

As his business soared, William Ives took a bride on May 12, 1824. She was Lucy Gardner of Hingham, Massachusetts, and by the time that Anne Abbot carried Eternal Happiness to W. & S.B. Ives on Essex Street in 1843, Ives and his wife had seven children.

A family man, a successful businessman and a "pillar of the community," William Ives seemed a solid sort, but unremarkable. He did fit the profile of the industrious, God-fearing Yankee who believed a man generally got exactly what he deserved in life. Befitting a family man who happened to be a publisher, Ives churned out religious and educational tracts for children, including a weekly children's magazine called *The Hive* from 1828 to 1830.

When Anne Abbot brought Dr. Busby to Ives in 1840, he had begun selling toys and other children's items and saw the potential of her idea. Her reappearance some three years later with Eternal Happiness would push Ives from the realm of the successful businessman to that of a cutting-edge "gamesman."

Ives soon crafted Abbot's idea into a sleek wooden game board embossed with sixty-seven squares leading to the players' ultimate destination—the Mansion of Happiness. Reflecting traditional Puritan tenets of moral rectitude, Abbot and Ives eschewed the use of dice with the game in favor of an eight-sided teetotum.

Across those sixty-seven squares, players advanced wooden pegs according to the whims of the teetotum and "prayed" that their pegs would find such spaces as Justice, Humility and Piety and avoid such pitfalls as

Poverty, Cruelty and Passion. A journey to the "mansion" comprised fascinating glimpses not only of Yankee religious values but also of the world according to a Massachusetts minister's daughter. Her virtuous squares featured images of healthy, beatific men, women and children. Piety depicted a kneeling "maiden" whose hands were clasped in prayer beneath a stately tree. Honesty showed a dignified man in a modest brimmed hat and a sober but well-cut frock coat, his features dour but filled with propriety.

To the minister's daughter, the picture of a demure young woman standing in front of a church symbolized Humility. Chastity, the young woman rendered on square thirty-one, appeared in plain garb and wore a similarly sweet expression, but without a church in the background.

In many ways, as the players raced their pegs from the first square, Justice (a long-haired young woman balancing the scales of justice but not wearing the blindfold), to the sixty-seventh, the Mansion of Happiness—a domed, pillared edifice framed by gracefully spreading trees and a lush lawn—over two centuries of New England's history, culture and traditions unfolded. Puritan punishments such as the stocks and the public pillory beckoned the Drunkard, a man lurching against a lamppost with his stylish top hat askew on square forty-seven, or the Perjurer, a roguish man lying to a magistrate on the forty-third square. A misfortunate turn of the teetotum dispatching players' pegs to such nefarious characters' squares decreed a loss of turn and a "humiliating" stint in the stocks or on the pillory.

For players who had navigated their pegs into the "home stretch"—within ten squares of the cherished mansion—the number fifty-seven posed one of the game board's more ominous pitfalls: the Robber. A sinister figure in his slouched hat, his demeanor remorseless, the thief was assailing yet another of Abbot and Ives's virtuous young women as she pleaded on her knees to no avail while the highwayman seized her cash and valuables. A visit to the Robber's realm resulted in the removal of a player's peg to prison for two precious turns.

Along with the sinners and "saints" players met along the winding route to the Mansion of Happiness, they encountered familiar and welcome New England sights. The Water, square six, presented two young couples in a rowboat on the ocean, one of the women clad in a stylish bonnet and one of the "beaus" manning the oars. Just nine squares into the journey, the Inn awaited, a slope-roofed, clapboarded structure, familiar and welcome for travelers in all corners of New England.

Square fifty guaranteed players a different sort of welcome. There, an edifice of grim granite blocks and barred windows and doors beneath a squat roof hinted of unspeakable dangers and evil. That stop—the Prison—often ruined players' chances in the race for the Mansion.

In parlors across New England and beyond, the race across Abbot and Ives's sixty-seven colorful squares delivered on the printer's promise that young and old alike would find the game "instructive, moral, and entertaining

amusement." Americans visited the Mansion of Happiness repeatedly, those sojourns not only confirming Abbot and Ives's creation as "the grandfather of all board games" but also ringing up profits for several decades.

Ives capitalized upon the Mansion's success by releasing other board games in the 1840s. In 1844, he offered customers Pope and Pagan, a forerunner of historically themed games that would swell into a lucrative niche of the toy industry. Mindful of the first successful games issued by his firm, Ives reissued Dr. Busby and unveiled other card games such as Characteristics.

Ives's success soon proved the truth of the axiom "imitation is the sincerest form of flattery." His first major imitator and competitor materialized in Springfield, Massachusetts, the interloper named Milton Bradley, who in 1863 introduced the Checkered Game of Life, published by Brooks & Brothers, a Salem rival of Ives. Rival George Parker went on to found Parker Brothers and a game called Monopoly.

William Ives, the board game trailblazer whose success had inspired George Parker and Milton Bradley and had launched the business with a distinctly New England sensibility, died on December 12, 1875, in his Salem home at 390 Essex Street. He had lived long enough to glimpse the board game mania he had ignited with Eternal Happiness and, unlike so many innovators who never reaped the profits of their notions, he had garnered financial reward.

A decade after Ives's death, Parker, paying the ultimate commercial compliment to his fellow Salem entrepreneur,

purchased all rights to five of Ives's games, including Dr. Busby and Eternal Happiness, despite Parker's pronouncement years earlier that Eternal Happiness was too "preachy" and not enough fun. He promptly reissued "the grandfather of all board games," America's first.

"Go Ask Alice"

In the Puritans' promised land in the 1670s, Alice Thomas, denounced as "a common Baud [*sic*]," unveiled a New World twist to the world's oldest profession. She was anything but "common" in her line of work, for Alice Thomas—"the Mass Bay Madam"—opened the Thirteen Colonies' first recorded brothel and catered to a wide range of Puritan party animals who would "go ask Alice" long before Grace Slick and the Jefferson Airplane recorded their 1960s rock anthem offering that very advice.

Prostitution arrived quickly in the Thirteen Colonies. In 1637, the first record of a colonial "working girl" referred to "this goodly creature of incontinency" who plied her trade near Boston to augment her meager income as a housemaid. By 1680, cases of "fornication, adultery, and whoredom" had doubled from 1640s levels in the "city upon a hill" (Boston). Puritan officials punished prostitutes and their male patrons equally; in stark contrast to 2009 authorities' penchant for meting out nothing more than legal "slaps on the wrist" to so-called "johns," Puritan johns faced the prospects of

stints in the stocks, jeering crowds and a constable's whip. Worst-case scenarios, specifically revolving around adultery, carried the possibility of a date on the gallows. Still, despite the danger, the world's oldest profession flourished in New England.

Doing her share for the "cause" in the early 1670s was Alice Thomas, a widow of indeterminate age and the owner of a shop of some sort near the waterfront in Boston's North End. Whatever legitimate wares Alice Thomas peddled in her store, she soon hawked merchandise of a different sort: strong spirits without a license and sexual favors—for a price. She employed half a dozen women, most of them maidservants in proper Puritan homes. Somewhat amazingly, the Widow Thomas and her staff thrived for several years, the local law looking away from the "stews," period slang for "brothel."

In early 1672, Alice Thomas's profitable sex trade started to unravel because of a nasty divorce case landing her brothel so squarely in the public eye that the authorities could no longer ignore her operation. The divorce war pitted Katherine "Nanny" Naylor, whose family, the Wheelrights, was one of the richest and most powerful clans in the Massachusetts Bay Colony, against her husband, Edward Naylor.

Nanny Naylor sued her husband for divorce on grounds of physical abuse, his impregnation of a household maid and his trysts at Alice Thomas's shop, where he allegedly partied evenings away in the embrace of a maidservant named Mary More. Before the general court

of Massachusetts on February 2, 1671, Nanny Naylor offered graphic testimony of her husband's brutality and his philandering and informed the judges that the couple's servant, carrying Edward Naylor's child, had fled to New Hampshire to avoid charges of adultery.

Following the victimized wife to the stand was John Anibal, a pillar of the Puritan community. "I have often seen Mary More and Mr. Naylor at the Widow Thomas's house together," Anibal testified. Before onlookers got the wrong idea, Anibal hurriedly assured the court that he had never entered the stews. On the request of Nanny Naylor, who had pleaded with Anibal, an old friend of the Wheelrights, for help, he related that he had discreetly followed Edward Naylor to Thomas's house and had peeked through one of the brothel's windows to catch Naylor and More in the act. Anibal emphasized that he had merely *observed* the festivities.

Nanny Naylor won her divorce, but her family and their formidable friends refused to let the scandal ebb. For the indiscretions of an upscale patron, Alice Thomas was to reap the proverbial whirlwind.

The repercussions slowly simmered. Late in January 1672, nearly a year after the rancorous Naylor divorce, a constable arrived on Thomas's doorstep and hauled the madam to the town house. Inside the steeply gabled, three-story frame structure, the legal and commercial nerve center of Massachusetts, Thomas stood before a magistrate and listened as charges were heaped upon her with the same rapidity as men had piled coins into the coffers of her sex shop.

The general court, denouncing Thomas as a "common Baud [*sic*]," caring little that she had hardly twisted the arms of Puritan johns, indicted her. The constables summarily tossed her into Boston Prison, "a house of meager Looks and ill smells on Prison Lane," where she would inhabit a cell until her day in court.

In late 1672, Thomas stood trial for five major crimes: "aiding and abetting theft by buying and concealing stolen goods; frequent secret and unreasonable entertainment in her house to lewd, lascivious and notorious persons of both sexes, giving them opportunity to commit carnal wickedness; selling wine and strong waters without a license; entertaining servants and children; and selling drink on the Sabbath."

Although the severe penalties for carnal cries were enough to terrify even the strongest souls, only rape, murder and incest usually incurred the death penalty. Still, Thomas had much to fear, for sometimes the court sentenced thieves to the gallows.

The judge pronounced a stiff sentence upon her. It ordered her to pay "threefold restitution" for fenced goods and also fork over a huge fine of fifty pounds sterling for her assorted crimes and court fees. The fines furnished the least of Thomas's woes. The magistrates commanded that she be forced to stand blindfolded on the town gallows for one hour with a noose around her neck while the court decided if she should hang for thievery.

The jurists decided to spare her the noose, but not the rest of her sentence. In freezing weather, the constables

stripped her to the waist, dragged her from the gallows, tied her to the back of an ox-drawn cart and levied thirty-nine lashes to her back with a large whip as the ox cart rumbled through heckling crowds. Finally, the constables returned the bleeding, battered woman to Boston Prison.

After several months of incarceration, Thomas learned of her neighbors' next swipe at her. The court had ordered that she be forever banished from Boston. In October 1672, Thomas was led down Boston Neck and out of town. She walked into exile.

Proper Puritans, believing they had seen the last of Alice Thomas, faced a shock: in July 1676, her petition for reinstatement won approval from the general court. Thanks to the profits of her sex shop, she had bought her way back into the good graces of the colony's movers and shakers by contributing to Boston's construction of a new harbor sea wall.

Thomas's second chance in Boston proved uneventful. This time, the Thirteen Colonies' first madam had shut off her red lantern for good.

"ROOM SERVICE"

Everything looked different. From the moment that the Tremont House in Boston opened its doors on October 16, 1829, a new world of comfort and service greeted the fortunate patrons to sample the amenities of America's first modern—as well as first world-class—hotel.

The Tremont House's soaring, dignified brick exterior and spacious entryway proclaimed that this establishment offered something special. When the first genteel guests strolled into the high-ceilinged, columned lobby and signed their "John Hancocks" in the bound-leather ledger resting atop a burnished mahogany reception desk, patrons began to grasp the unprecedented accommodations that awaited them.

Unlike all other American inns and hotels of the era, the Tremont provided single rooms. Guests venturing into other hostelries were accustomed to proprietors frequently rooming complete strangers "spoon fashion" in a single filthy bed (one wonders how much sleep some customers got worrying if the snoring stranger alongside them was some sort of miscreant). As a European traveler recalled, he would lay half-awake all evening in America's inns "worrying about who might slide into bed with him." Even worse, owners of such "hospitality suites" often attempted in a pinch to pile strangers of both sexes under the same bedcovers. A raffish young Englishman wrote of "a late night" in a New York inn "when five young ladies came into [his] room" and began to disrobe for bed. "I raised my head," he later wrote, "and desired to be informed which of them intended me the honor of her company." The women smiled at him—and arranged a bedroll for themselves on the floor.

Some guests at America's inns reveled in situations like that of the young Englishman. A popular travel anecdote of the late eighteenth century told of a staunchly religious

Connecticut woman who harangued her nephew for his womanizing "on the road." The nephew explained:

> *But we're not so very different. Suppose that in traveling, you came at an inn where all the beds were full except two, and in one of those was a man and in the other was a woman? Which would you take? The woman's to be sure. Well, madam, so would I!*

Such was the hotel scene of the 1800s until the Tremont opened its 170 rooms to the public, or at least to the well-heeled public able to afford the new hotel's pricey two-dollar-per-night rate.

When the Tremont's patrons wriggled their room keys into their singles' locks, another hospitality innovation emerged, for the Tremont was the first hotel to provide individual locks and keys. The guests, upon entering their rooms, tastefully decorated and featuring clean, comfortable beds, encountered other unprecedented amenities: a washbowl, a pitcher and a cake of soap for each visitor. In other hotels, roommates shared all of the above. The Tremont's guests did not even have to worry about knocking over bowls or pitchers in the dark—rooms came equipped with innovative gas lamps with which the clumsiest fingers could cope.

If the hotel's patrons did have trouble figuring out how to use the lamps or any of the Tremont's other conveniences, yet another new marvel of technology provided help. Each room came equipped with an "electro-magnetic annunciator" featuring two buttons. All any guest had to do

was press the buttons and the annunciator set off a small, quivering disk in the main office to dispatch employees to the room in which the customer had a request.

Although high society seldom praised the Tremont's attentive staff because of "the belief that too many compliments to servants made them forget their station," some of the highborn patrons' loftiest praise went to two working-class heroes: the hotel's plumbers, Thomas Philpot and Thomas Pollard. The "princes of pipes" had installed private bathrooms—yet another hotel first—replete with flush toilets, earning plaudits as modern miracles from guests and tradesmen alike.

The society sorts who soon ventured from their private bathrooms and plush digs headed down the hotel's sweeping staircases to its elegant dining room. There, repasts turned out by world-class chefs and served on fine china atop costly white linen tablecloths conquered the privileged palates of people for whom only the best fare would do.

One frequent guest at the Tremont House discovered in the glittering dining room what he believed to be the landmark hotel's true secret of success, and that secret was not the sumptuous food delighting diners. "You eat in a crowd," wrote the Reverend George Lewis, "sitting down with fifty, a hundred, sometimes two hundred at a table, to which you are summoned by a sonorous Chinese gong. The only place of retirement is your room, to which you have your key." Later chroniclers of American life would agree with Lewis's assessment that the Tremont's revolutionary balance between public and private ways,

"this congenial mix," was the "cunning sum of its [the Tremont's] achievement."

The stellar reputation of the Tremont House bloomed from the first day its magnificent doors opened, many among the era's high and mighty embarking on pilgrimages to Boston for no other reason than to stay at the hotel. Throughout the nineteenth century, anyone determined to build a first-class hotel in America looked to the "Bible"— a book entitled *A Description of the Tremont House with Architectural Illustrations.*

Unfortunately, many of the Tremont House's imitators outlasted the original. In 1895, developers purchased the still-popular establishment with the intention of building a bigger and better hotel. The "palace of the people" fell victim to the wrecker's ball. An era had ended, but in the gleaming lobbies and plush suites of today's finest hotels, the traditions of the Tremont House flourish. America's first modern hotel had proven worth every penny of its steep two-dollar-per-night rate.

"PILGRIMS' PROGRESS?"

William Bradford, Myles Standish, John Alden, Priscilla Mullins—the names are the stuff of popular legend, and rightfully so, for they were courageous souls who endured mind-boggling hardships to forge a foothold in a wilderness. Others in the Plymouth settlement, however, had a harder time adjusting to life in the New World.

Crime, while not anywhere near the scale of Boston, seeped into Pilgrim life.

In 1638, some eighteen years after the *Mayflower* landed, a rising number of housebreaks, petty thefts and assaults compelled William Bradford to order the construction of the Pilgrims' first prison; its necessity distressed the settlers, as for nearly two decades they had made do without one. They completed the jail in 1641, a two-story structure twenty-two feet long and sixteen feet wide and situated between the home and land of two of Plymouth's founding families, the Fullers and the Hicks. John Mynard, the jail's builder, received "three pounds more…besides his dyett [*sic*], for his work donn [*sic*] about the prison over & above the bargaine [*sic*]."

In Plymouth, the Pilgrims displayed far more forbearance and tolerance than the Puritans to the north. Bradford and his fellow settlers never made adultery a capital offense. Whippings occurred with far less frequency in Plymouth County than in the rest of the colonies. Most of the "guests" of the Plymouth jail were drunkards and vagrants known as "coasters," or brawlers, with some adulterers thrown into the mix.

Although Plimoth Plantation saw less crime than Boston, even the Pilgrims encountered the worst or saddest aspects of human nature. Some crimes committed in the land of the Pilgrims proved too terrible for even the charitable William Bradford to comprehend.

One such crime rocked the Pilgrims in 1642; the deed resulted in America's first execution for a sexual offense. Bradford, his anguish over the dark episode evident, described the case, the sad saga of a troubled young settler:

> *A youth whose name was Thomas Granger; he was servant to an honest man…being about 16 or 17. He was detected this year of buggery and indicted for same with a mare, a cow, two goats, five sheep, calves, and a turkey. Horrible it is to mention, but the truth of the history requires it. He was first discovered by one that accidentally saw his lewd practise towards the mare. I forbear particulars…he not only confessed the fact…[but also] the rest of the forenamed [charges] in his indictment…and accordingly he was cast by the jury, and condemned, and after executed on September 8, 1642. A very sad spectacle it was; for first the mare, and then the cow, and the rest of the lesser cattle, were killed before his face, according to the law…and then he himself was executed.*

Another dreadful first of American crime—the first woman executed for murder in the colony—unfolded in Plimoth Plantation. Her name was Alice Bishop, and she was charged with "felonious murder by her committed, upon Martha Clark, her own child, the fruit of her own body." The unnerved Pilgrims recorded only a sparse record of the crime. Nothing is known of the life of the murderess except that she perished at the end of a rope dangling from a Plymouth tree.

For the Pilgrims and the Puritans, any dreams of a promised land free from wickedness had disappeared; the sins of the Old World had inevitably sprouted in the

New World. By the onset of the eighteenth century, the age-old struggle between good and evil raged full force in the land of the Separatists (the Pilgrims) and the Saints (the Puritans).

"SIR WILLIAM, ARISE"

Royal Londoners had never witnessed such a scene. In June 1687, a round-faced, genial-looking colonist knelt in front of the bewigged James II, the long-faced Catholic king soon to lose his throne to his Protestant foes. As the monarch's court, ministers and ladies in silk, lace and gems watched, "the homely Colonial" waited for the king to bestow upon him an honor many of the courtiers had yet to garner: British Knight of the Realm.

The kneeling American, William Phips of the Massachusetts Bay Colony (his part of the region later to become Maine), would become the first native-born American to be thus honored. The reason for the honor lay in another first, one in which he had risked life and limb to chase a fortune in gold and jewels: the colonist had achieved wealth as America's first undersea treasure hunter.

William Phips was one of twenty-six children born to James and Mary Phips, English colonists who settled in what would later become Maine along the Kennebec River. Their boy William was trained as a ship's carpenter but yearned for adventure. In 1683, he traveled to London and won an appointment in front of King Charles II with a

proposal to add gold to the royal treasury, the Exchequer. The mariner's scheme proved too intriguing for the Crown to ignore—even though the plan was conceived by a rough-around-the-edges colonist.

When Phips's interview with the king arrived, the American did not kowtow at the sight of the royal court's movers and shakers. Instead, the colonist spun a tale of treasure waiting for someone bold enough to salvage a sunken ship laden with gold, silver and gems. Of course, there were a few hitches to Phips's dreams of ocean booty: the vessel was a Spanish treasure ship resting in Spanish waters off the Bahamas, and England and Spain were mortal foes; Phips needed money—lots of it—to mount an expedition complete with a ponderous "diving bell" and scores of men, some of whom could certainly perish in the depths surrounding the wreck. If a squadron of Spanish warships was suddenly to arrive on the wreck site and discover an English salvage team, Phips and crew would end up beneath nooses or as slaves chained to the oars of Spanish galleys.

Despite the dangers of the idea and the high probability that any money invested in Phips by the Crown would be lost, the picture of glittering booty scattered on the ocean floor and the chance to tweak Spain's collective nose by selling the loot from under it proved too seductive for Charles to decline. The king outfitted Phips with an armed naval frigate and a crew and dispatched the adventurer to the warm waters of the Bahamas.

Phips returned to London in 1684—empty-handed. He discovered that his benefactor, Charles II, had died

and another Stuart, James II, now wore the crown. James displayed his opinion of Phips's dream by seizing the treasure hunter's ship.

Phips immediately sought new financiers in England and quickly sold the Duke of Albemarle and other noble investors upon the idea of a second salvage operation, this venture to a Spanish treasure ship sunk by a hurricane off Hispaniola (Haiti). Phips and his new crew of salvagers set sail in 1686.

Phips's expedition eluded the Spanish and located the wreck site. Braving brutal diving conditions and the ever-present threat of discovery by the enemy, Phips's wildest dreams materialized: his men emptied the sunken hulk of £300,000 sterling worth of gold, jewels and pieces of eight, a staggering fortune stolen from Spain.

Phips's arrival in London in June 1687 proved worthy of a Roman triumph, the adventurer receiving a bonafide hero's welcome replete with cheering crowds and fawning nobles. The colonist had not only delivered stunning profits to his investors and, of course, a required cut to the Exchequer even though the Crown had not financed him, but he had also emerged a wealthy man from his own share of the booty.

Phips's next audience with James II proved vastly different from the first. The daring American approached the throne and knelt; then, in the age-old gesture of England's monarchs, James tapped Phips's shoulders with the flat of a sword.

"Sir William, arise," the king intoned. "It is my pleasure to create you a Knight of the Realm."

James had ample reasons to feel "pleasure"—the Crown's cut of the treasure snatched from England's mortal enemy Spain rested at a hefty 10 percent.

America's first knight appeared unimpressed with the ceremony. To the Duke of Albemarle, the treasure hunter's friend and partner, Phips said: "I am at heart a Puritan. My place is in New England." He soon returned to his homeland a rich Puritan. In New England he remained,

serving stints as provost marshal and royal governor of Massachusetts before his death in 1695. The Puritan's path to colonial power was paved with the Spanish loot he had stolen from the ocean's depths.

"YOU CAN'T TEACH AN OLD DOG NEW TRICKS"

Dismay darkened Governor John Winthrop's thoughts. Standing before him inside the rude pine walls of Boston's first meetinghouse in the late fall of 1630 was a man with ample reason to dread any twitch of Winthrop's pointed black beard, any hard glint in his eyes, any clench of his jaw. For the object of the governor's scrutiny, as well as that of seven other high and mighty leaders of the fledgling Massachusetts Bay Colony, had reminded fellow Puritans that they could not escape in the New World the basest human instincts of the Old World. Walter Palmer, a man who had stepped ashore with Winthrop and the other settlers of Boston scant months ago, now stood accused of murder—the murder of another Puritan.

To Palmer, the gravity of his predicament could not be overstated. He would hang if convicted, the first Puritan so punished. He had already achieved a dubious first: the "honor" of appearing as the first case ever brought before a Puritan court in Boston.

If Palmer knew that one colonist, Pilgrim John Billington, had been hanged at Plimoth Plantation less than a month before in September 1630, the Puritan had reason to

break into a cold sweat at the grim prospect of sharing Billington's fate. Palmer had one thing in his favor: unlike the Pilgrim killer, Palmer had not murdered a man in cold blood, but allegedly in self-defense. The dilemma for the accused Puritan lay in convincing his jury and the judges of that fact. In the general court, where lawyers were banned, Palmer stood alone, armed only with his version of the spat that had ended in a fatal fistfight.

Palmer faced a charge of manslaughter, a crime whose price tag was a trip to the gallows or a sturdy tree limb if no scaffold was handy. He could not deny that he had thrashed Austen Bratcher to death, so as the survivor of the fray opened his defense, his hands still bruised for all to see, his chances of convincing the jury of his innocence appeared tenuous at best.

Palmer claimed that Bratcher had provoked the fracas first with insults and oaths and then with a sudden flurry of punches. Unfortunately, Winthrop's journal never catalogued the reasons behind the quarrel, but the governor did write that "Austen Bratcher died as a result of strokes given by Walter Palmer." That Palmer had given better than he had got had saved his life from Bratcher's fists and feet. Against the magistrates pondering Palmer's entreaties, his fistic prowess could avail him little. Words now composed the only weapon of the tradesman.

Palmer finished his testimony and stood braced against the prisoner's bar while a stream of neighbors—men in tall, brimmed hats, in woolen doublets or leather jerkins, in breeches, stockings and buckled shoes, and women in

prim bonnets, capes and layered petticoats to ward off fall gusts—testified before the jury and the judges. Eyewitnesses to the brawl split on who had instigated it. Finally, after the witnesses in the Puritans' first trial had painted their varying verbal renditions of Palmer versus Bratcher, the jury huddled to deliberate the evidence and, most importantly, their gut feelings about Palmer's veracity.

Palmer had to worry most about Winthrop's gut feeling, for the taciturn leader of the Massachusetts Bay Colony had hoped that the Puritans—his Puritans—would live free of sin as God's chosen people, the latter-day Israelites. "The Lord will make our name a praise and glory," Winthrop had proclaimed at the settlement's founding, "so that men shall say of succeeding plantations: 'The Lord make it like that of New England…We shall be like a City upon a Hill; the eyes of all people are on us.'" Many of his fellow Puritans had heard the words from the governor's lips.

The telltale moment loomed. Palmer was to learn whether he would twist beneath a rope or live among Winthrop's "saints." Across the crowded benches and the rough-hewn walls of the first meetinghouse, the jury's verdict echoed: "Innocent by balance of evidence."

Walter Palmer had dodged the hangman. Still, if Winthrop and company hoped that their little settlement on the Shawmut Peninsula would prove a haven from mayhem, disillusionment lurked at the ready. Throughout Puritan New England, the Ten Commandments would take a beating, and colonists would commit astonishing transgressions not to be found in the original commandments or any code of law the Puritans would devise.

A ROYAL SCANDAL

In May 1887, Boston rolled out the red carpet for a royal visitor, one the *Boston Globe* called "the dusky Queen Kapiolani, mistress of the Sandwich Isles [Hawaii]." From the moment that the queen and her large retinue checked into the tony Parker House and hotel officials raised "the ensign of Hawaii" atop the building's flagstaff, Boston's mayor, Hugh O'Brien, the city's and state's legislators and Brahmins fell all over themselves to impress her. "The most disgraceful affair in the history of junketing in this city" was unfolding, and the "royal scandal" would swirl about the mayor, a man who had risen far above his beginnings and had done so by prudent management of city funds. Or at least until Queen Kapiolani swept into town.

Only about two and a half years before the "mistress of the Sandwich Isles" settled into a Parker House suite, Hugh O'Brien had reveled in his own status as the toast of Boston, for he had been sworn in as the city's first Irish-born mayor on January 5, 1885. To many Yankees and Brahmins, his ascent represented a once unthinkable development in a region notable for its antipathy toward Irish Catholics.

O'Brien's odyssey to the top of the heap in Boston politics began in 1832, when his parents emigrated from Ireland to Boston with their five-year-old son. He displayed a considerable intelligence early on but was yanked from the city's public school system as a twelve-year-old to

work as an apprentice to a printer for the *Boston Courier*. A tradesman's future beckoned the youth, lucky that he could escape the low-paying and insecure street sweeping or dockside work so many of his fellow Irish immigrants were forced to take. Young O'Brien, however, set his eyes on a far loftier future—one amid the rarefied circles of Yankee commerce.

Following his stint at the *Courier*, O'Brien took a slot at the private printing firm of Tuttle, Dennett and Chisholm on School Street, learning the ins and outs not only of printing but also of publishing his own paper, the *Shipping and Commercial List*. His publication proved a smash hit among Yankee merchants and Brahmin financiers who depended in any way upon the flow of goods and business news across Boston's docks. The Irish Catholic had garnered quite a feat in making himself indispensable to well-heeled Protestants whose Back Bay and Beacon Hill brownstones generally meant only one thing to immigrants of "the old sod"—backbreaking work as maids or handymen. Brahmins who mocked "Paddy, the hopeless, witty Irishman, given to drink and quick to tears and laughter, who loved nothing more than 'rows and ructions,' and Bridget, the chaste and prudent but comically ignorant serving girl," looked grudgingly at O'Brien in a different light. Many upscale sorts began to view him as an anomaly—one of the "good Irish."

O'Brien's business value to New England merchants and moguls notwithstanding, the question of how far the ambitious publisher could rise among the "Irish-hating ice-

cicles of Yankeeland" intrigued local Democratic leaders who ruled the city's Irish neighborhoods. In 1875, the forty-nine-year-old businessman won election to Boston's Board of Alderman, and the watchful eyes of the Irish community noticed when, over the next seven years, even hard-boiled Yankees lauded his "conscientious hard work."

As a self-made man embracing New England traditions of industriousness and self-discipline, O'Brien belied the vicious stereotypes of "Paddy and Bridget" espoused by Brahmins inside their boardrooms, clubs and mansions and by Yankee tradesmen on construction sites and in local watering holes. The burgeoning Democratic luminaries of the Irish community first put O'Brien's political palatability to Yankees to the test in late 1883 by nominating the publisher and alderman as the party's mayoral candidate.

In the weeks before voters hit the polls, many Yankees recoiled against the notion of an Irish-born mayor. Then they attacked his character—but not with the ethnic "ammunition" many Bostonians expected. The *Boston Transcript*, the political conduit of conservative Protestants, did not assail O'Brien's birthplace or his "Papist" religion, but raised allegations of his "junketeering" as an alderman.

On election night, the Irish turned out in force for their candidate, a man whose financial outlook shared more in common with his Protestant and Republican foe, Augustus Martin, than with fellow immigrants. O'Brien lost the election, but by a narrow margin.

A year later, the name of Hugh O'Brien once again topped the Democratic mayoral ticket, and enough Yankee

voters swallowed misgivings about an Irish-born candidate to help the immigrant poor sweep him into office. His campaign platform of lower taxes and his demonstrated ability as an alderman to back that promise had proven a fiscal siren song too sweet to resist for many Brahmins.

Hugh O'Brien took the oath of office on January 5, 1885, heralding a new political era for Boston and for the region. He wasted little time in keeping his campaign promises of sound spending and lower taxes, worked to improve the city's parks and roads and helped to lay the groundwork of the Boston Public Library, a site where even "Paddy and Bridget" would be allowed to read and study.

Off to such a promising start in the mayor's office, O'Brien won reelection in late 1886, and as the first few months of 1887 passed, his conservative hand on the proverbial tiller of the city's finances continued to earn him the trust of even the stodgiest Yankees. Trouble, however, loomed for the mayor in the guise of a royal visitor accustomed to the finest surroundings money could buy. The guest's first-class tastes would stir up a first-class financial mess.

Determined that Boston's accommodations would prove literally fit for a queen, the Parker House, "on hospitality intent," spared "no expense...in preparing the rooms for their royal occupants." As Queen Kapiolani and her retinue moved about her suite, she found it crammed with flowers, including a special arrangement—the Hawaiian words for "I Love You" emblazoned "in letters of red immortelles upon a bank of similax and ferns." Local florists handed "carte blanche" by city officials to decorate

the queen's suite had created "bowers of floral beauty" in each room.

Later, inside the stately Arlington Street Church, the customary eloquence of Reverend Phillips Brooks vied with the sight of "the strange visitors" for his parishioners' attention, "the most fashionable set in town" straining for glimpses of the ruler of the exotic islands. The scene repeated itself at a service at historic King's Chapel, where the queen and her retainers settled into "quaint, high-backed pews" and "formed the center of attraction for the staid churchgoers who cling to the church of their fathers."

Following the service at King's Chapel, Kapiolani enjoyed one of the few lulls in her Boston sojourn. The "visitors…[were] allowed to follow their own inclinations" before the "official courtesies" that would captivate New Englanders for the next week. No one yet knew that the civic and financial fallout of the upcoming week was to turn intrigue into outrage.

A reporter commented that, beginning with breakfast on Monday, May 9, 1887, the queen and her retinue were "not allowed much time to waste in idleness." Over breakfast in her suite at the Parker House, she received civic dignitaries and assorted Brahmins, the region's moguls and mavens dressed tastefully and fashionably for their chat with the monarch. Aside from deferential bows, nods from the society set and dignified gestures from the queen, those who had brief audiences with Kapiolani could only speculate about "her opinions concerning the very elaborate official

courtesies of which she is the recipient." A reporter wrote that he wanted "to chronicle her opinions" but could not because "the Hawaiian language is not generally understood in Boston."

Shortly after the receiving line in the queen's suite receded, she was driven to the Old South Church. There, she stared at Revolutionary War artifacts, "manifesting great admiration for the heroes of 1776."

The next stop on Kapiolani's itinerary was an official breakfast, if a noontime meal could truly be considered breakfast. Mayor O'Brien hosted the affair in special honor of Kapiolani, the strains of an orchestra wafting above crowded tables, the fragrance of yet another elaborate floral exhibition filling the room. The gathering comprised Boston's "glitterati," guests distinguished in municipal affairs, politics, literature and society, "each gentleman accompanied by a lady." In one onlooker's assessment, the meal and the following reception proved a smashing success.

The guest of honor capped off her whirlwind Monday with an evening at the theatre—two theatres, the Boston and the Globe, to be exact—where, once again, surrounded by Boston's high-born and highly placed, she attracted more attention than the onstage action.

Although Queen Kapiolani would spend a week in town, the official high-water mark of her sojourn came on Tuesday, May 10, 1887, with her visit to the State House. Senator Morse of Canton, Massachusetts, was delivering a speech from the podium. Suddenly, the senate chamber's

massive doors were flung open. Morse fell silent. Sergeant-at-Arms Adams, "in all the glory of his tall hat, ornamented with a rosette and carrying the official mace," strode into the main aisle and stopped.

"Her Majesty, the Queen of the Sandwich Islands!" the sergeant-at-arms proclaimed.

Senate President Boardman cracked his gavel, and every man in the chamber stood. Preceded up the aisle by Adams, Queen Kapiolani sashayed between rows of Democrats and Republicans who generally behaved in that room with far less decorum than they showed to the "mistress of the Sandwich Isles." In turn, the monarch bowed gravely to the state's power brokers.

For the rest of Kapiolani's stay, her rounds of nonstop official breakfasts, lunches, dinners, receptions and tours continued, as did nightly visits to the Boston and the Globe Theatres. By the time the queen's sojourn in Boston ended, everyone who was anyone had met her.

Within a few weeks of the queen's departure, the bills for her visit came due. Mayor O'Brien found himself confronted with a public relations nightmare precluding business as usual. "Scandal Over the Bills for Queen Kapiolani's Entertainment"—this and other such headlines filled the newspapers in late May 1887.

O'Brien, who had overcome previous allegations of a penchant for "junketeering," scrambled to cover the first bills of the queen's junket—$18,000, a staggering amount given her weeklong stay. Boston's citizens were outraged at the figure, but only the mayor and his staff knew that the

reported $18,000 was just the beginning of the monarch's expenses. Many of the larger bills, including the hefty tab for the week's lodging and meals at the Parker House, had not been detected by the press, and the mayor and his staff wanted to keep it that way.

The bills already revealed to the public ignited "the biggest kind of row." Among them lay an invoice for $4,500 worth of flowers from the Galvin brothers. Crowed a reporter: "Even Councilman Whall, Chairman of the Entertainment Committee, blushed when this bill was presented."

At first, O'Brien refused to pay the Galvins. When they threatened to stir up trouble for him, the mayor, immersed in a financial furor escalating into a bonafide scandal, settled up to head off any "row [that] would have caused all the facts to become public property…[as] this would not do." By paying the Galvins, "a sensation was spoiled."

The Galvins' "sensation" proved merely one of many for the mayor in the financial fallout of Kapiolani's visit. A coverup commenced. Creative bookkeeping, the press charged, revealed that the Parker House had billed the city a suspiciously modest $2,800. In the frenzy of questionable accounting, politicians buried, relabeled or paid outrageous bills privately. One of the most notorious bills undisclosed to the public came from the Victoria Hotel, which had hosted an official reception for the queen and her retinue. About one hundred guests had attended the fête and had rung up a bar tab for over one hundred gallons of assorted liquor. A reporter remarked that, by his estimate, each guest downed a gallon of spirits.

The scandal died slowly, Mayor O'Brien's reputation for efficiency allowing him in large part to weather the controversy. The furor did not derail the career of Boston's first Irish-born mayor, who would win reelection in 1887. In the minds of some locals, though, Queen Kapiolani's sojourn left a "black eye" on the city's political visage. Most Bostonians agreed with a reporter who labeled the royal visit as "the most disgraceful affair in the history of junketing in this city."

A COMRADE IN ARMS

On June 17, 1775, behind battered earthworks, the Rebel poured the last traces of powder into his musket and rammed home his last ball. Bodies were strewn all around him, some in homespun colonial shirts stained with blood, many more dead and wounded clad in the scarlet coats and white cross-belts of George III's regulars.

Minuteman Peter Salem, a sturdy, twenty-eight-year-old laborer, steeled himself, as did the Rebels around, for the climax of the battle. Although hundreds of redcoats lay sprawled on the grassy slopes beneath the American redoubts, groans and sobs pealing through the clouds of smoke, the British were forming columns again for a third charge.

With a rattle of drums and the tramp of boots and buckled shoes, the red wave moved slowly up Breed's Hill, the roofs and steeples of Charlestown shimmering

in the haze behind them. Some of the colonists manning the breastworks took a quick glimpse of their own homes among those roofs for the last time.

Closing the gap, the redcoats leveled their bayonets, many stained crimson. Salem scanned the oncoming mass for a target who was preferably an officer. According to many accounts, a Rebel colonel had cried, "Don't fire until you see the whites of their eyes!" In repulsing the first two charges, Salem and his comrades had obeyed that dictate.

With a collective howl the redcoats broke from a quick walk to a run and swarmed across the redoubts. The Rebels' muskets barked and scores of the British toppled. Still, they kept coming. Slowly, the Patriots gave way, edging backward from their defenses.

A British major cried, "The day is ours!"

Salem's musket cracked and its ball tore through the officer's head.

Back in April 1775, Salem had stood with his fellow Minutemen at Concord and had seen that same officer order his redcoats to clear the town green of Rebels. Now, as Major John Pitcairn crumpled to the ground, a hated symbol of British tyranny went down.

Peter Salem, the man who had killed Pitcairn, was not just any Minuteman. He was a black man and a slave, and amid the carnage of the Battle of Bunker Hill, he became America's first black war hero. Years later, painter John Trumbull would feature Peter Salem in a famed painting of the clash.

Peter Salem was born into slavery in 1748 or 1749 in Framingham, Massachusetts, the property of Dr. Jeremy Belknap. The slave spent days working on Belknap's small farm and running endless errands for the physician, but nonetheless paid attention to the growing dissension between colonists and the British. Even when he was sold to another Framingham man, Lawson Buckminster, Salem stood among slaves and freed slaves alike eyeing the coming struggle as a potential means to a new life in a new order. Historian Sidney Kaplan wrote, "When the embattled farmers fired the shot heard round the world, it is probable that in New England most blacks saw their destiny, if only dimly, in the triumph of a democratic revolution that might somehow, in the shakeup of things, give substance to its slogans [of freedom for all]."

When the Minutemen gathered at the North Bridge in Concord on April 19, 1775, Peter Salem stood with them, his musket primed. Still a slave, he had been allowed by his master to volunteer with Simon Edgel's company of Framingham Minutemen. Drilling shoulder to shoulder with whites who owned slaves, Salem prepared for his chance to prove himself in the fight for freedom. After each drill ended, he returned to his slave's quarters.

As Salem slept in his shed on the evening of April 18, 1775, some seven hundred redcoats began a roughly twenty-mile march from their Boston billets with orders to seize the Minutemen's stores of powder and shot in Concord. Rousted from sleep with the other men of Edgel's company by the alarm of a rider, Salem grabbed his musket

and powder horn, scrambled to his place in the ranks and marched to Concord.

The redcoats reached Lexington early on the morning of April 19, 1775. On the village green, some seventy men—mainly tradesmen, merchants and farmers—faced the neat columns of redcoats. Among the Minutemen stood several blacks, including Pompey, a slave from Braintree; Brookline resident Joshua Boylston's slave Prince; Cuff Whitmore; and Cato Wood. A future black minister named Lemuel Haynes also claimed a spot among the Patriots, and of that day's clashes he would write about "the inhuman Tragedy Perpetrated on the 19th of April 1775 by a Number of the British Troops…which Parricides and Ravages Are Shocking Displays of Ministerial & Tyrannic Vengeance."

As the colonials on the green refused to disperse, Major Pitcairn shouted, "Lay down your arms, damn you! Why don't you lay down your arms?"

The "shot heard 'round the world" rang out—no one knows whether a redcoat or a Minuteman squeezed the trigger. Ragged volleys followed, with 8 colonists falling dead. The rest fled from the green and dashed with other Minutemen to Concord. They joined with several hundred other colonists to drive the redcoats from the North Bridge and force them "to run with greatest precipitance." Throughout the long, bloody April day, the first of the Revolution, Peter Salem fired at redcoats as he crouched behind stone walls, houses and barns almost all the way to Boston. By nightfall, at least 270 redcoats were killed or wounded. The man who many

Rebels condemned for having "caused the first effusion of blood" was Major Pitcairn.

Along with his master—Lieutenant Buckminster—Salem and several hundred other Rebels crawled some eight weeks later across Charlestown Neck past British sentries. General Artemus Ward had ordered the Patriots to "dig in" on the steep slopes of Bunker Hill, but the troops mistakenly fortified Breed's Hill, a lower incline.

When an unseasonably hot day broke across Boston, British commander Thomas Gage went into a rage at the sight of the entrenched colonists. He summoned his officers and ordered them to prepare a direct frontal assault, rejecting the sound advice of General Henry Clinton to attack the Rebels from the rear as well.

As 2,500 regulars piled into longboats and were rowed to Morton's Hill, British warships opened up on the Rebels and were joined by batteries on Copp's Hill, in the North End. Salem and his comrades huddled behind their makeshift earthworks as the cannonballs tore up chunks of Breed's Hill and claimed a handful of men.

Finally, the bombardment lifted. Salem and the other Patriots lifted their heads and stared at a chilling scene. Dense columns of redcoats, their regimental colors nodding in the wan breeze, the sun glinting off neat rows of bayonets, advanced down Morton's Hill, crossed the small level meadow leading to Breed's Hill and surged up the slope in perfect order toward the Rebels' redoubts. The British drums thumped louder. Several colonists wavered and then bolted down the back of the slope. From a warship in the

harbor, British General "Gentleman Johnny" Burgoyne would write that the advancing redcoats furnished "one of the greatest scenes of war that can be conceived." But he also would note that "a defeat [at Breed's Hill] would be a final loss to the British Empire in America."

As the first wave of regulars approached the bastion, the order to hold fire "until you see the whites of their eyes" echoed among Salem and the other colonists. Suddenly, a deafening roar burst from hundreds of colonial muskets. The muzzles' smoke covered the hill's summit for a long moment. Then, as gaps in the smoke appeared, the colonists saw the redcoats fleeing down the slope, leaving scores of dead and wounded behind them. A cheer burst from the breastworks.

The Rebels' shouts ebbed as the British reformed their ranks and, once again with the rattle of drums, tramped up the hill in close order, officers marching with their swords leveled at the colonists. For a second time, they neared the earthworks and another jarring volley cracked from the massed Patriots. The British lurched back to the bottom of the hill, leaving hundreds more lifeless or writhing redcoats on the slope.

Some of the Rebels believed that the battle was over, a stunning victory against King George III's vaunted regulars. With colonial powder horns and cartridge boxes nearly empty, relief at the apparent end of the fray filled many of the Rebels.

At the bottom of the hill, sergeant majors and officers were swiping the flats of swords at the men who had survived

the two charges. Slowly, the scarlet columns reformed. The drums boomed again and regimental colors shredded by musket balls reappeared above the men's heads, many of them bare because the Rebels' volleys had knocked bearskin shakos and black Monmouth, or tri-cornered, hats from their owners.

The regulars moved forward for the third time. Panic washed across the colonists as the bayonets neared, the redcoated ranks trampling their dead and wounded as the distance to the redoubts narrowed. Scores of British slipped on the blood-stained grass, fell and climbed right back into line.

Sporadic volleys flared from Rebels down to their last few shots. All around Salem, Patriots fled as the British surged across the redoubts and drove their bayonets into buckling colonists. "Among the foremost of the leaders was the gallant Major Pitcairn, who exultantly cried 'the day is ours,'" a colonist would recall. "Salem, a black soldier… shot him through and he fell." Another Rebel would write that "a Negro man…took aim at Major Pitcairne [*sic*], as he was rallying the dispersed British Troops, & shot him thro' the head."

Moments later, Salem joined his fleeing comrades with his musket still in hand and, as British musket balls whizzed past, stumbled to safety up Bunker Hill.

Although the redcoats had chased the Rebels from their hilltop perch, the victory was truly Pyrrhic, the British having suffered 228 dead and 828 wounded, a staggering casualty rate of 42 percent (10 percent is considered high by military experts).

As the man—or one of the men, according to some scholars—who killed the infamous Major Pitcairn, Salem merits consideration as the first black hero among the slaves and manumitted slaves on the greens of Lexington and Concord and at the redoubts of Bunker Hill. Samuel Swett, the first colonist to write about the Battle of Bunker Hill, claimed that "[Salem] was presented to Washington as having slain Pitcairn."

During the battle, painter John Trumbull watched the carnage from Roxbury, across the harbor. The artist, at the least, heard of Salem's feat and would remember it eleven years later when he put brush to canvas in one of his most famous works, *The Battle of Bunker Hill*. In the lower right-hand corner of the canvas, Trumbull conferred artistic immortality upon Salem, depicting him in the midst of the mêlée as a handsome young man clad in a thick homespun shirt and clutching the musket with which he downed Pitcairn. The painter's image of Salem resembled the few references to his robust, pleasant visage, later prompting historian Sidney Kaplan to state that Trumbull "possibly met" Salem shortly after the battle.

Although Peter Salem won acclaim for his famous musket and for his likeness in Trumbull's painting, other black soldiers served valiantly at Breed's Hill. Swett wrote that, like Salem, a black youth named Cuff Whitemore "fought bravely in the redoubt…He had a ball through his hat… fought to the last, and when compelled to retreat, though wounded…he seized the sword [of a redcoat officer] slain in the redoubt…which in a few days he unromantically

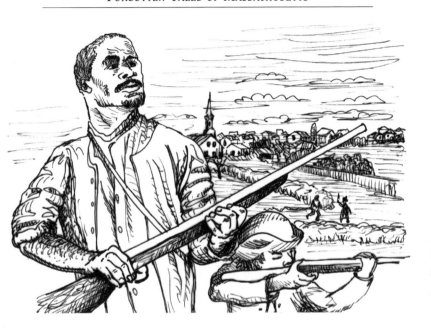

sold. He served faithfully through the war, with many hairbreadth 'scapes from the sword and pestilence."

Another of the blacks who fired at the whites of the redcoats' eyes also bore the name Salem—Salem Poor. Unlike Peter Salem, the twenty-eight-year-old Poor was a free man, married and even a member of Andover's otherwise white Congregationalist church. He had enlisted in Colonel Benjamin Ames's company. In the aftermath of Breed's Hill, fourteen Rebel officers who had fought there sent a remarkable petition to the Massachusetts General Court. The letter was the first battlefield citation for a black soldier in the nation's annals, Patriot hero Colonel William

Prescott adding his name to the other officers beseeching "the Reward due to so great and Distinguisht [*sic*] a Caracter [*sic*]" as Poor.

The petition stated:

> *The Subscribers begg leave to Report to you Honble House (Which Wee do in justice to the Caracter of so Brave a Man) that under Our Own observation, Wee declare that a Negro Man Called Salem Poor…in the late Battle of Charleston* [sic], *behaved like an Experienced Officer, as well as an Excellent Soldier, to Set forth Particulars of his Conduct would be Tedious, Wee Would Only begg leave to say in the Person of this sd. Negro Centers a Brave & gallant soldier.*

Aside from the officers' plaudits, Poor received no reward. He served nearly to the war's end, mustered out in 1780, a veteran of Valley Forge and many battles.

Salem Poor, in 1775, already possessed what Peter Salem and other black soldiers craved: freedom. Later that year, when Salem enlisted in George Washington's Continental army, his owner, Lawson Buckminster, granted the slave liberty.

Salem proved the kind of soldier Washington prized most, one who did not shoulder his musket and head home after three months of enlistment. The ex-slave carried his acclaimed musket to Saratoga, Stony Point and many other battlefields of the war, firing it with the same deadly effect as he had at Breed's Hill. On March 1, 1780, he was mustered

out of the army. No white soldier could charge that Salem had shirked his duty.

Salem headed back to Massachusetts and soon settled in Leicester to find that, for freed blacks, earning a living posed problems. He could find odd jobs from local farmers and tradesmen, but for pittances. When he married Katie Benson, a pretty ex-slave, Salem had learned the old New England skill of weaving cane into bushels, sewing baskets and furniture. Now he turned to the craft for a living and discovered no lack of customers among local housewives and shopkeepers. In a plank cabin he built himself on a small Leicester lot purchased with his back pay from the Continental army, he ran his own shop, and when business slowed, he loaded up a small hand cart with his cane goods and peddled them from farm to farm.

Above his cabin's tiny fireplace, Salem hung his musket, and whenever a customer commented on the relic, Salem would recount its vivid history. Local boys often showed up at the ex-soldier's cabin, with or without a basket that needed mending or an order for a new one, and pleaded with Salem to tell his adventures again and again. He always obliged. When he passed the children's parents in the roads of Leicester and Framingham, they nodded respectfully to the man who had shot Major Pitcairn.

For thirty-five years, Salem and Katie, a paid domestic, made enough to keep up their cabin's repairs and to feed and clothe themselves decently. To their disappointment, they never had children.

In the winter of 1815, Katie caught a chill and died within a week. Peter Salem toiled to keep his cane-weaving business going, but his heartache and his fingers, now inflamed by worsening rheumatism, forced him to give up weaving. Unable to earn money and too proud to beg, he left his cabin unlatched on a late fall day in 1815, walked to Framingham and entered the poorhouse. In January 1816, Peter Salem died there in his sleep at the age of sixty-six or sixty-seven.

By 1855, even the measure of fame Salem had earned at the Battle of Bunker Hill had faded. A historian of the era noted that the most recent accounts and images of the battle contained "a significant but inglorious omission" —any mention of Salem.

The commemoration of the Bunker Hill Monument in the early 1880s revived public interest in the heroes of the legendary clash, and scholars grudgingly began to accord Peter Salem his historical due. In 1882, the citizens of Framingham erected a monument honoring Salem, further resurrecting his name. Today, John Trumbull's painting of *The Battle of Bunker Hill*, with its vivid depiction of Salem, hangs in the rotunda of the Capitol in Washington, D.C. The Leicester cabin in which Salem lived has been restored.

The Bunker Hill Monument in Charlestown, Massachusetts, contains an even more tangible relic of the slave who won his freedom in America's War of Independence: in a glass case at the memorial lies his scarred musket.

SETTING THE TABLE: THE REAL FIRST THANKSGIVING

The image colors America's collective imagination. Pilgrims sit shoulder to shoulder with stoic Wampanoag Indians at long wooden tables laden with mouthwatering entrees. The settlers are dignified men with shoulder-length hair beneath tall, wide-brimmed hats; demure women in pristine bonnets and well-cut petticoats; children as miniature versions of the adults, everyone garbed in sober hues of black, white and gray.

This scene composes the Thanksgiving of American memory—and of American myth. The realities surrounding this holiday notion, however, are decidedly different than most Americans realize.

As history records, William Bradford, Myles Standish, John Alden, Priscilla Mullins and the rest of the legendary band who founded Plymouth in December 1620 and survived their first harsh New England winter had much to be thankful for in August 1621. Only fifty-five of the more than one hundred original settlers had survived to see the first thaw, but their ensuing labors had paid off with a bountiful harvest. The fields had yielded such a surplus that Governor Bradford proclaimed a day of thanksgiving.

Setting aside a thanksgiving of prayer and fasting was a common enough practice among the early Massachusetts colonists. But the resilient Pilgrims, beset by short rations throughout Plimoth Plantation's first winter, were of little

mood to proclaim a day of fasting. Bradford and company opted for a harvest feast and tendered an invitation to the local Indians, the Wampanoag, who had helped with the cultivation of the colonists' crops.

One can only wonder how thrilled Plimoth Plantation's cooking crew—4 women and 2 teenage girls—was by Bradford's brainstorm: a meal for 50 or so colonists and 90 or more Wampanoag. As the colonial chefs of the repast for approximately 150 diners began to stoke cooking fires and to arrange giant kettles, the colony's men also had errands to run before the stew pots simmered. Pilgrim Edward Winslow recorded, "Our governor sent four men fowling [hunting], so that we might…rejoice together." With fresh game on the cutting board and with oysters, clams and fish available from the nearby Atlantic Ocean, the 4 women and 2 girls set to work slicing, dicing, stewing and roasting the bounty of field, forest and sea.

The day for the settlers and the Indians to celebrate arrived sometime between September 21 and November 9, 1621. Wampanoag chieftain Massasoit and at least ninety of his fellow Indians strode into the palisaded Pilgrim village to the sight of long, rough-hewn wooden tables piled with victuals. In the brush strokes of many future artists, the feast's hosts and hostesses appeared serene and robust and wore soberly colored clothes. But the real settlers, who had survived starvation, illness, cold and backbreaking toil, probably looked haggard and careworn; the Pilgrims' clothes displayed a hodgepodge of hues—green, russet and various browns, as well as black and gray.

The Pilgrims' toil had paid off; their Thanksgiving menu offered varied, plentiful, yet vastly different fare than the mythical "turkey and trimmings." Although roast turkey surely appeared on the table, as the birds thrived in the thickets along Cape Cod Bay, the diners probably sampled as much duck, goose and partridge as turkey. To the menu, not to mention the Pilgrim women's chores, the Wampanoag, gracious guests, added their own taste twist with a gift of five deer.

As for any American today who believes that the first Thanksgiving featured traditional trimmings, well, guess again. No mashed or roasted potatoes, no breads or rolls and no butter to smear upon them sat atop the tables of Plimoth Plantation. Because the cooks possessed neither flour nor molasses in the cupboard, no fragrant pumpkin pie nor any other pie tickled the nostrils and the palates of the Pilgrims and the Wampanoag. The diners ate their pumpkin boiled and plain.

Equally unappetizing to today's tastes would have been hasty pudding and boiled corn, fashioned by Pilgrim women into mush and sometimes fried into corn cakes. If a lump of hasty pudding would send modern Americans dashing from the table at Plymouth, imagine their dismay to discover that the Pilgrims had no bowls of gravy to pour upon their turkey. Various scholars have suggested that the Pilgrim women boiled wild cranberries into a sauce of sorts for the bird; unless the cooks blended wild honey into the sauce, diners' mouths were subjected to the tartness of the berries, which left

one the option of taking one's turkey dry. To wash down bits of gobbler, no pitchers of apple cider graced the feasters' tables. Another future Thanksgiving staple absent at the Pilgrims' party was stuffing. All in all, the menu of the first Thanksgiving hardly offered the stuff of future holiday dinner dreams.

Other myths shroud the first Thanksgiving. Artists have depicted the Pilgrims as outnumbering their Wampanoag guests at the legendary celebration and have portrayed the Indians in headdresses and costumes more appropriate for Wild West scenes than Massachusetts in 1621. Massachusetts artist Karen Rinaldo has rendered a historically accurate tableau in comparison to the highly romanticized and fanciful canvases of past painters.

Rinaldo's vivid image captures the look of thatched-roof cottages and palisade fences of the fledgling seaside colony; around the food-laden tables, she presents fifty-two Pilgrims and ninety-two Wampanoag, a more realistic tally of the colonist-to-Indian ratio at the landmark feast. The Wampanoag of Rinaldo's work appear not in headdresses and buckskins, but in the tribe's actual garb of breechcloths and leggings.

Rinaldo's version of the food, the faces and the vistas of the first Thanksgiving is the closest that any viewer will get to a glimpse of the mythical feast. Her work reveals the months of painstaking research she undertook when she was commissioned by the National Association of Congregational Christian Churches to create a true-to-life painting of the first Thanksgiving.

The artist's quest for historical accuracy, aided by experts at Plimoth Plantation, was not without controversy. Various historians assert that Wampanoag women attended the Pilgrims' feast. But Wampanoag sources told Rinnaldo that tribal traditions and the diplomatic underpinnings of the celebration would have brought only the tribe's men to the harvest celebration; therefore, she refrained from rendering Native American women in her work.

Rinaldo's landmark painting was unveiled in 1996 at the Pilgrim Hall Museum in Plymouth, Massachusetts. It was opened to the public in May of that year as the centerpiece of a six-painting exhibit commemorating the 375th anniversary of the first Thanksgiving.

When asked what she hoped the public will take away from her painting besides an accurate look at the first Thanksgiving, Rinaldo replied, "I hope it serves as an educational scene. But, more, that it really illustrates important traditional values and virtues, hard work, the importance of family and community and acceptance of differences among people. It sounds simplistic, yet after 375 years, these same values of the Pilgrims still remain key."

As Rinaldo's words and work reflect, no myth cloaks the true meaning of Thanksgiving.

THE PIONEER POETESS: ANNE BRADSTREET

Wintry gusts rattled the diamond-shaped windowpanes of her clapboard house. With her free hand, she pulled a

shawl closely around her shoulders and then nudged her chair a few more inches toward the hearth, where a winter fire blazed with more noise than effect against the drafts. Upstairs, her bed, piled high with thick coverlets, beckoned. Still, she stayed huddled over sheaves of paper and dipped her quill in a vial of ink. Anne Bradstreet, America's first published poetess, was at work.

Anne Bradstreet was born in or near Northampton, England, in 1612. Her father, Thomas Dudley, a staunch Puritan and a veteran of the army of "good Queen Bess," Elizabeth I, had made the acquaintance of a noble, the Earl of Lincoln, who favored Puritan beliefs. Dudley went to work for the earl as the steward of Lincoln's estate, including Sempringham Manor, and the Dudley children grew up in the rarefied surroundings of royalty, a lifestyle at which most hardworking Puritans could only gape. Young Anne Bradstreet, as she strolled through the earl's lush gardens, gained a love of nature's beauty and a fascination with her own: later, she acknowledged that she had been vain about her appearance.

Along with her interest in her appearance, Anne Dudley was consumed by another passion: a love of learning. Her father's growing wealth allowed him to hire tutors for his daughter, and the earl gave the girl free rein in his voluminous library. The steward's daughter was soon as well read as the spoiled offspring of many nobles.

When Anne turned sixteen, she caught the heart of twenty-five-year-old Simon Bradstreet, her father's assistant steward. Her later writings indicate that she fell deeply

in love with him. He was a man on the rise, the son of a minister and an ambitious young man with a master's degree from prestigious Emmanuel College. The couple married in 1628, and their love would stretch across more than forty years of incredible joy and hardship alike.

One of the first hints of personal hardships to come was Anne Bradstreet's bout with one of the era's dread diseases, smallpox, in the first year of her marriage. She survived, but that the illness left scars upon her young psyche was

undeniable. She was to write that during her suffering she prayed for forgiveness of her vanity and that God cured her. Her use of the word "vanity" hints that she may have seen the disfiguring disease as a warning against too much pride in one's physical charms.

Anne Bradstreet's world changed forever when civil and religious strife racking England grew worse after Charles I gained the crown in 1625. There was ever-increasing antipathy from the Church of England toward the Puritans, who eschewed the state church's ceremonies and symbols as smacking of Catholicism. By 1630, Puritan leaders were alarmed by assaults upon some of their ministers and by Charles's dissolution of three Parliaments, signaling that the land was on the brink of civil war. The time had come, many Puritans decided, to pull up stakes and find their New Canaan, a promised land where, like Israel's tribes of old, the Puritans could worship in their own way. In 1630, with her husband, her parents and other members of her family, Anne Bradstreet stood on the deck of the *Arbella*, flagship of a four-vessel fleet laden with Puritan passengers led by John Winthrop. As she stared at the slowly vanishing docks and cottages of Southampton, she must have known that she was never to glimpse England again and that the memories of her life amid the earl's gardens, the Lincolnshire countryside and precious volumes of his library were all she would have against the frightening uncertainties of the New World. Leaving behind all that she had known was a shock to the refined Puritan wife, merely eighteen, a shock she alluded to in her future work.

In May 1630, seventy-two days after the *Arbella* slipped away from Southampton, Bradstreet and her fellow passengers crowded the gunwales for their first look at the New Canaan. Many praised God for their deliverance; others were too weary or sick from scurvy and other ailments to care.

At first the springtime splendors of the land, with its wild strawberries, dense, fragrant stands of pines and warming sunshine, heartened the new arrivals. But one glance at the gaunt colonists who had survived the previous winter in Salem and in Charlestown filled the hearts and souls of Winthrop's band with dread. Later Bradstreet recalled her fear that God had cast her and the others into a hellish wilderness. How she must have longed for England's tidy gardens and civilization in the first days after setting foot on Massachusetts soil.

The Bradstreets' New England winter thrust them into the same frantic struggle for survival that they had seen in May in the sickly faces of their predecessors to the colony. In their house in Cambridge, near present-day Harvard Square, the family shivered alongside smoldering fires, never able to chase bone-numbing cold. The Bradstreets and Dudley survived, Thomas Dudley recorded, on clams, mussels, acorns and any other scraps of food they foraged with freezing fingers.

Anne Bradstreet may not have realized at the time that the harsh new life in New England was to stoke her creative flame, for she was preoccupied with lasting long enough to see the spring of 1631, not to mention battling a severe case

of culture shock. Slowly, her Puritan upbringing gave her the faith to accept her plight as God's will.

The Bradstreets survived the winter of 1630–31, and well educated and better heeled than most of their neighbors, Simon Bradstreet and Thomas Dudley surged to the front rank of the fledgling colony's political affairs as the decade unfolded. The 1630s also brought children to the Bradstreets, their first, Samuel, born in 1633.

For Anne Bradstreet, who had often cried from fear that she was never to conceive, her family was the center of her life, as was true of any God-fearing Puritan mother. She gave birth to her daughter Dorothy in 1634, but as was often the case in the seventeenth century, the aftermath of labor nearly killed the new mother when she suffered an illness diagnosed as consumption, a catchall for a variety of the era's maladies. She lived, but the illness was a portent of ailments to come.

By the time the Bradstreets and their four children settled permanently in Merrimack (now North Andover) in 1643 or 1644, the Puritan wife's health was not only building up well enough to let her run her household with all the skill a husband could want but also allowing her to continue another labor she had begun soon after her arrival in the colony. This labor was one of love, a link to past days spent blissfully in Lincoln's library. Anne Bradstreet, who had tried her hand at verse as early as the age of nineteen, was writing poetry in Merrimack. A poet's voice, muted at first, meant only for her family, had been stirring in the wilds of the Massachusetts Bay Colony. America's first female poet was at work.

In 1650, Anne Bradstreet discovered that she was a published poet. The Reverend John Woodbridge, her brother-in-law, had gathered some of her poems and had them run off by a London printer called the Sign of the Bible. The first printed verse by an American woman was long-windedly entitled *The Tenth Muse Lately Sprung Up in America. Or Severall Poems, Compiled with Great Variety of Wit and Learning, Full of Delight...By a Gentlewoman in Those Parts.* To many on both sides of the Atlantic, the existence of such a book caused more astonishment than the volume's poems: a colonial woman had summoned the colossal nerve to present her jottings for publication.

Actually, Bradstreet did not know what her brother-in-law had done until the book was printed. He acknowledged her ignorance of his scheme and wrote of his concern that she might be peeved at him for having spirited away her work without her approval.

The name of the "gentlewoman" was not mentioned with the book's title. Her identity came to light in the preface, where readers in Old and New England learned that the "Tenth Muse" was Anne Bradstreet. The book's introduction also noted that the poetess was not a woman who allowed her children to go hungry, her garden untended or her laundry unwashed as she wondered whether a couplet or a meter rang sweetly to the ear. Instead, she was a woman who picked up her quill only after her household tasks were done, a woman who sacrificed a few hours of sleep, not her family's welfare, on the altar of her muse. The introduction's depiction of her as a prim and proper Puritan

housewife appears the likely work of Bradstreet's "agent," John Woodbridge, intended to defuse any questions that seventeenth-century minds might raise about the moral character of any woman allegedly taking time from her household duties to write poetry, to some minds a frivolous pastime and to others a vocation of men.

As she later proved, the entries contained in *The Tenth Muse* were the efforts of a poetess to bloom, but one without a unique voice—yet. Her first volume reflected the influences of other writers, including several French poets and Sir Walter Raleigh; her early poems were often derivative, reflecting the knowledge she had accrued in the earl's library rather than the experiences, novel to the mindset of her readers back in England, of a gentlewoman starting life over in a wilderness teeming with natural wonders, endless hardships and death. "A Dialogue Between Old England and New" was the only poem in *The Tenth Muse* that gave readers a true glimpse of the voice developing within the soul of Anne Bradstreet. The voice was to be that of America's pioneer poetess.

As a poetess, Bradstreet hit her stride in the 1650s and 1660s. Whenever she sat at her writing table and dipped her quill into ink, she drew upon her experience to pen vivid, often surprising insights into the mind of a Puritan housewife.

Bradstreet devoted much of her most memorable work to her husband, Simon, who often left his wife and children behind while traveling to Boston on political business. In the early 1660s, he sailed for England to plead for the favor of the

new king, Charles II, who had received scanty support from the colonists at his restoration to the throne in 1660. Despite fears that her husband might perish on the long voyage or that the king might toss him into a rank cell in the Tower of London, Anne Bradstreet showed her backbone by running her household with Puritan precision and by continuing to compose verse. Her ardor for Simon shone especially in her work entitled "To My Dear and Loving Husband":

> *If ever two were one, than surely we,*
> *If ever man were loved by wife, than thee.*
> *If ever wife was happy in a man,*
> *Compare with me ye women if you can.*

Again and again her love for her husband blazed in many of her verses: in "A Letter to Her Husband, Absent upon Publick Employment," "As Loving Hind" and other poems from the quill of the remarkable Puritan woman.

Anne Bradstreet wrote also of the joys and the sorrows of giving birth and of rearing children, her "eight birds hatcht in one nest." Some of her most poignant work ruminates on the deaths of several of her grandchildren and on the death of a daughter-in-law who perished during childbirth, a particularly heart-wrenching event for Bradstreet, who had nearly gone to the grave during her daughter Dorothy's birth.

With a soul-searching honesty welcome in poets of any era, Anne Bradstreet not only examined marital life but also hinted at thoughts most Puritans kept under tight rein:

thoughts of her sexuality. Here she was on tricky turf, for one misstep could earn censure from shocked neighbors. Still, she admitted in an essay that as a teenager in England she had entertained sexual thoughts sinful to many right-thinking Puritans.

As Anne Bradstreet's work matured in the 1650s and 1660s, it reflected a poet seeking life's truths in religion, love, family, marriage and death. The themes were hardly novel to lovers of verse, but her voice, chiming with increasing grace and a better technical grasp than her first poems had displayed, rose from a unique setting: the American wilderness.

From that setting came the work that many labeled her masterpiece, "Contemplations." It was an ambitious effort linking Bradstreet's religious reflections and nature. Critics may argue that her workmanship seems callow alongside most European poets of the day, but in the wilds of New England during the mid-seventeenth century, a unique poetess was at work.

That Bradstreet was able to write meritorious poetry amid the rigors of pioneer life was the true measure of her talent and her dedication to her craft. Her health always tenuous, the demands of raising eight children taxing, so often left alone by her husband to fend with the incessant demands of running the Bradstreet household and to face the natural dangers of New England, she somehow juggled her dual roles as housewife and poetess.

In 1666, Bradstreet's house burned to the ground. The ashes of the Bradstreets' eight hundred or so books, a huge collection by colonial standards, smoldered in the blaze's

aftermath; some of the poetess's verses likely vanished with her family's library. Thankfully, much of her work did survive the calamity.

In 1678, a second collection of Bradstreet's work, *Several Poems Compiled with Great Variety of Wit and Learning*, was printed in Boston. The book's scope and its technique surpassed her first effort and proved that Bradstreet, having honed her skills with the passage of years, was a poetess who had inhaled deeply of life and had infused her work with a wide range of emotions and experiences rooted in both the Old and the New World.

Anne Bradstreet was never to see her second book. In the fall of 1672, she was stricken again with consumption. She was about sixty years old, buffeted by the burdens of her life in New England. According to the anguished memory of her son Simon, she wasted away, her body wracked by pain, one of her arms grotesquely swollen. Finally, the light passed from her eyes. The doomed poetess had welcomed death in her final stanzas:

> *Lord make me ready for that day*
> *then Come deare bridgrome Come away.*

Seven of her children survived her, and her husband, Simon, lived into his nineties. One of her sons, Dudley, was suspected of witchcraft, but the charges were dropped. Roughly two centuries after her death, one of her descendants carved a niche for himself among America's literary luminaries; his name was Oliver Wendell Holmes.

Anne Bradstreet's poems left a glimpse into the mind, heart and soul of an extraordinary woman. Her verse belies the assumptions of any who think that New England's Puritans were all dour souls for whom "love" and "joy" were alien words.

Out of the Famine and Into the Abyss: The Tragedy of the Brig St. John

On October 7, 1849, the *St. John*, five weeks out of Galway Bay and packed with Irish immigrants fleeing the Great Famine, was hurled by a gale onto the crags of Grampus Ledge off Cohasset, Massachusetts. A second "coffin ship" (as the overcrowded vessels were known), the *Kathleen*, grounded nearby on a sandbar, but the *St. John* broke in two on the rocks. Immigrants and crewmen thrashed in the foaming surf. Eyewitness Elizabeth Lothrop wrote that "no human power could stay the waves," which pulled the brig "deep into the depths of Hell."

On the shore, the "boatmen" of Cohasset—Yankees with little affinity for the Irish—left prejudice on the beach as they tried again and again to launch the town's lifesaving boats into the crashing surf. In the end, they managed to aid only the *Kathleen*. Most of the *St. John* passengers were doomed. Over the next few days, forty-five bodies washed ashore and the townspeople buried them in a common grave. An exact total was never known. Between eighty-six and ninety-nine Irish immigrants drowned. Eleven survived.

The tragedy claimed one last victim on the Cohasset shore. An Irishwoman who had rushed to the scene from Boston in hopes that her infant daughter and her sister had survived the shipwreck found their corpses beneath a sheet on the sand. "The infant [was] tightly folded in the sister's arms," Lothrop remembered. The mother died of an apparent heart attack.

In 1914, the Massachusetts Loyal Order of Hibernians raised a nineteen-foot Celtic cross above the victims' common grave. On October 7, 1999, local Hibernians, along with dignitaries from County Galway, gathered at the monument to mark the 150th anniversary of the wreck. On display from the Cohasset Museum was all that's left of the ill-fated brig: a trunk, a small writing desk and a piece of pulley.

"BAH, HUMBUG": IN MASSACHUSETTS'S EARLY DAYS, EBENEZER SCROOGE WOULD HAVE FELT MORE AT HOME THAN SANTA

Ebenezer Scrooge would have loved colonial Massachusetts—at least until his Yuletide conversion. Instead of "Merry Christmas," the local holiday watchwords could have been "bah, humbug."

Streets teeming with holiday shoppers, stores emblazoned with decorations, Christmas parties at schools and churches, food and presents for the needy—none of these sights graced early Massachusetts. For nearly the

first two centuries of Massachusetts's existence, there was not a Christmas tree to be found on December 25, nor a Christmas candle, stockings hung by the fireplace, carols or holiday decorations of any sort. The reason was simple enough: the Puritans of New England loathed Christmas, denouncing it as a "Papist," or Roman Catholic, pastime that had no place in a proper New England community.

The settlers who arrived in Massachusetts throughout the 1600s brought their deeply held religious tenets with them, and as the colony slowly grew throughout the seventeenth century, locals embraced the "Christmas" views of fellow New Englanders such as Pilgrim stalwart Governor William Bradford. Bradford had a large hand in shaping the colony's opposition to any Yuletide observance. "On the day called Christmas Day," an early history of Plimoth Plantation notes:

> *A few newcomers to the community asked to be excused from work, and he* [Bradford] *tolerantly said that he "would spare them until they were better informed." But he then discovered that they were determined to celebrate "at play, openly," as they traditionally had in England. He took away their implements of sport and sent them indoors.*

Bradford wrote that he labored to crush "pagan mockery" of the observance. Back in England, Oliver Cromwell, leader of the Puritan Revolution and the man from whom many New Englanders took their social and religious cue,

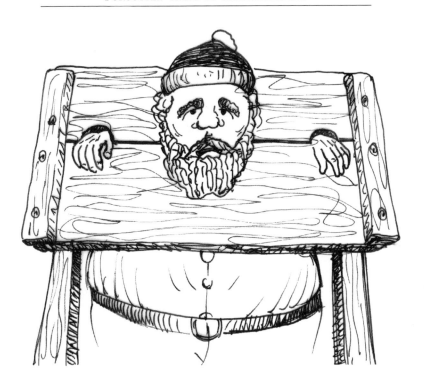

ranted against "the heathen traditions" of Christmas carols, decorated trees and any "idolatry" that desecrated "that sacred event."

For the Puritans of Massachusetts, Cromwell's and Bradford's actions earned staunch support. The colonists decried Christmas out of their abiding conviction that December 25 was a "Catholic holiday." In contrast to the Catholics' traditionally exuberant celebrations of Christmas, the early English settlers of Massachusetts

were determined to purify and simplify religious belief and practice. They wanted to "prune away" all trappings and trimmings of a "traditional Christmas." In the years from 1650 to 1681, the celebration of Christmas was outlawed in the region. The general court of Massachusetts decreed that any observance of December 25 (other than a solemn church service) constituted a crime and locals were fined for hanging decorations.

In early nineteenth-century Massachusetts, the "bah, humbug" approach to Christmas still thrived, as most residents refused to recognize Christmas as a holy day or to celebrate it with any semblance of gift giving, parties or decorations. One look at the era's diaries, letters and account books reveals that for most people in Boston and surrounding towns, December 25 was just another cold winter day. Unless December 25 fell on a Sunday and people attended their regular services at the town's churches, business as usual governed Christmas: stores, shops and taverns stayed open, and children went to school.

In the 1840s, as the Victorian era hit New England full-bore, Christmas in Massachusetts began to change. A social historian notes:

> *But with the beginning of the nineteenth century, the need for a festival to have some commemorative time made the Americans embrace Christmas as a perfect family holiday. Christmas was declared as a national holiday for celebration on June 26, 1870. And that was not all; Americans even re-invented the Christmas*

celebration and transformed it from a mere carnival into a family-oriented day of feast, fun and frolic.

Boston, a city that was built on family and community virtues, soon embraced the holiday that previous generations of locals had abhorred. So, too, did the rest of the state. Locally, the influx of Irish Catholic immigrants who celebrated Christmas also changed the holiday landscape, literally so. One of the Yuletide's most vivid symbols, the Christmas tree, began appearing in some genteel Massachusetts homes in the 1840s in large part because they had the personal stamp of approval of Britain's Queen Victoria:

> *In 1846, the popular royals, Queen Victoria and her German Prince Albert, were sketched in the* Illustrated London News *standing with their children around a Christmas tree…what was done at court immediately became fashionable not only in Britain, but with fashion-conscious East Coast American Society. The Christmas tree had arrived.*

Notwithstanding the queen's social influence, when it came to the now-popular Christmas tree, Massachusetts residents did things the "American way": it was noted that Europeans used small trees about four feet in height while Americans liked their Christmas trees to reach from floor to ceiling.

Other European Christmas touches sprouted in Massachusetts by the 1890s, with Christmas ornaments

arriving from Germany and household holiday decorations now the norm. A historian writes:

> *The early 20th century saw Americans decorating their trees mainly with homemade ornaments, while the German-American sect continued to use apples, nuts, and marzipan cookies. Popcorn joined in after being dyed with bright colors and interlaced with berries and nuts. Electricity brought about Christmas lights, making it possible for Christmas trees to glow for days on end. With this, Christmas trees began to appear in town squares across the country and having a Christmas tree in the home became an American tradition.*

Those words describe the Christmas scene of turn-of-the-twentieth-century Massachusetts. In the colony and, later, state where locals had once frowned on the holiday, it was "beginning to look a lot like Christmas." "Merry Christmas" had replaced "bah, humbug."

THE LITTLE HOUSE ON WASHINGTON STREET: IN FEBRUARY 1863, AN ACTOR NAMED JOHN WILKES BOOTH CAME TO MASSACHUSETTS

In late February 1890, a lean, gray-haired man rang the bell on the door of a small Boston house. A carriage that had conveyed him from a Boston hotel and would carry him back stood outside on Washington Street. Footsteps

sounded from a staircase within and a woman opened the door. The man did not state his name, but politely asked her if he might be allowed to enter, as he had lived there nearly four decades ago. For the moment she did not recognize the sallow face. She soon would, for it was the visage of nineteenth-century America's most famous actor—"the Prince of Players"—and one of the greatest Shakespearean thespians in history. She allowed him to come upstairs. With her permission, he stepped inside one of the bedrooms and gently closed the door. He reappeared a few minutes later and, his eyes misting up, told the woman that his beloved wife had died in that very room. Then he thanked the tenant and walked down the stairs to his carriage.

Edwin Booth would never set foot in Dorchester or Boston again. Once, the little house on Washington Street had been home to the actor, his wife, Mary Devlin Booth, and their little girl, Edwina. In February 1862, another actor named Booth had strode through that same door. His older brother Edwin had electrified audiences on the stages of Boston and virtually every great city in America and Europe. The younger Booth would shock the nation at another theatre, Ford's Theatre, in Washington, D.C., where in April 1865 he placed a derringer to the back of Abraham Lincoln's head and became the most reviled actor in America's annals.

In 1861, Edwin Booth was the toast of Boston's theatre community with his astonishing performances as the leads in some of Shakespeare's most memorable plays. Among the society types who opened their hearts and purses to the

famed actor and his family was Bostonian Julia Ward Howe, of "Battle Hymn of the Republic" renown. She referred to him as "Great B" and to Mary as "Little B." Edwin Booth's chief interest at such soirees lay not in meeting nabobs and society mavens—"Like being dragged to hell to go meet a set of damned fools," he groused to Mary—but in imbibing liquor, and lots of it.

Booth's schedule called for a series of performances in New York during the winter of 1862–63, and Mary and their infant Edwina went with him. Mary, however, had been ailing, and a Boston doctor urged her to spend the winter in a quiet setting and not amid the clutter, filth and fast pace of Manhattan. With consumption wracking her lungs, Mary and Edwin chose Dorchester partly because of its "healthful country setting" and mainly because Dr. Erasmus Miller, one of the area's most famous consumption specialists, lived nearby. Mary Booth wrote to a friend, "He [Dr. Miller] has inspired me with a great deal of faith. All agree in saying that he is *wonderful!*"

The Booths rented a small house on Washington Street. Booth biographer Eleanor Ruggles writes in *Prince of Players*:

> *Its little windows at the back overlooked a snow-covered slope undulating down toward Dorchester Bay; you could see ice-skimmed water from the bedroom window. There was a great deal of sleighing, but Mary was not up to it. Hopefully each morning of this cold January 1863 she stood in front of her mirror and pinched her cheeks to see if they had grown fuller.*

They had not.

Edwin Booth packed in crowds at the Boston Theatre in late 1862, earning the stunning sum of $5,000 in his two weeks there. Still, his bills were immense, and his money always "seeped out again in a dozen directions." In addition to his financial woes, worry about his wife's condition made him "sick as hell." He and Mary quarreled over his upcoming February 1863 performances in New York. She insisted that she would go; he was dead set against the idea.

In mid-January 1863, she climbed out of her bed in the Dorchester house and accompanied her husband to the Boston Museum, where the play *The Apostate* was in the midst of a triumphant run that was shattering the records that Edwin Booth had just set at the Boston Theatre. The "extraordinary" actor who packed them in as *The Apostate*'s villainous "Pescara" and whose "hot breath was on Edwin's neck" was John Wilkes Booth. The older Booth, however, felt more pride than competition when it came to John.

In Dorchester, Edwin Booth found a sense of calm that he had rarely experienced in his travels. Ruggles notes, "Booth loved Dorchester and the country life. He planned moonlight sleigh rides when Mary should be well enough."

Although Booth blinded himself to Mary's worsening health with such comments, as he left her for his run in New York, that she was in the "bloom of health and hope," her condition steadily declined in February 1863. John Wilkes Booth, on his way from Boston to Philadelphia in mid-month, got off his train in New York and rushed to his

brother's apartment to warn him that Mary was "ill with a feverish cold."

Edwin Booth remained in Manhattan, taking the stage in some sort of denial that his wife would not live. On the evening of February 20, 1863, Mary grew weaker, and Dr. Miller and a colleague told her that she had but a few hours left. She pleaded with the doctors to keep her alive long enough to see her husband for the last time. Dr. Miller rushed off in the snow to send an urgent telegram—his fourth in the past few days—to New York. The message asked: "Why does not Mr. Booth answer? He must come at once." This time Booth rushed to the train station and dashed off a telegram to Dorchester. It read, "MARY, I'M COMING."

He was already too late. In the bedroom of the Washington Street house, Mary Devlin Booth died a few minutes after 7:00 a.m. on February 21, 1863.

When Booth arrived, he closed the bedroom door and spent the night sitting next to Mary's body. No one bothered him until dawn.

The funeral services were held at Mount Auburn Cemetery in Cambridge, and during the solemn, heart-wrenching proceedings, Julia Ward Howe noticed not only the sorrow-wracked husband, "his eyes heavy with grief," but also the man at Edwin Booth's side throughout the service, John Wilkes Booth, "a young man of remarkable beauty."

Few locals who saw John Wilkes Booth on Washington Street or on the Boston stage would ever have guessed that the gifted young actor would become the assassin of

Abraham Lincoln just over two years after Mary Devlin Booth's funeral. The Booths' travails and deeds composed a family tragedy that the Bard himself might have been hard-pressed to surpass.

THE HANGING JUDGE

In 1692, Judge William Stoughton frowned from the bench at the misfortunate Salem men and women accused of witchcraft. His long, white hair flowing beneath his black skullcap, he appeared the living embodiment of an Old Testament judge, and the justice he dispensed helped send Salem's "witches" to the gallows. Unlike his colleague Judge Samuel Sewall, who later expressed his shame and regret for his role in the hysteria, Stoughton went to his Dorchester grave without ever making a public recantation—only, according to later sources, a tacit acknowledgement that he had done the best he could with the information available to him at the time of the witchcraft debacle.

William Stoughton was born on September 30, 1631, the son of Israel Stoughton, who was one of Dorchester's founders. Although it remains murky as to whether William was born in England or Dorchester, he went on to graduate from Harvard in 1650 and boarded a ship for England, where he would continue his education at the New College in Oxford, studying for the ministry.

He received his MA from Oxford in June 1653 and became curate of a Sussex church in 1659. Shortly

afterward, with the Restoration stripping much of the Puritans' power and placing Charles II on the throne, Stoughton lost his post.

Believing his prospects in England bleak, he returned to Dorchester in 1662 and preached at the town's church for several years. He was paid for his services to the town's worshipers but, when offered the pastorship, he declined. Politics and law were beckoning the ex-curate. He contended that his decision was compelled by "reasons within himself."

His choice to step from the pulpit to politics notwithstanding, in 1668, Stoughton stood in front of the general court in Massachusetts Bay Colony and delivered one of the "most powerful and impressive discourses" in the region's history to that point. Known as the "Election Sermon," Stoughton intoned that "God sifted a whole Nation that he might send Choice Grain over into this Wilderness." That Stoughton viewed himself as one of those "choice grains" appeared obvious.

By 1681, he was serving as one of the Massachusetts Bay assistants, helping to run the colony. He would hold the post until 1686, but was hardly limited to that position. As a commissioner of the United Colonies, his power increased, and he expanded his influence by serving as judge on a number of Massachusetts courts.

Stoughton's home and landholdings in Dorchester testified to his status as one of the colony's most prominent figures. His spacious, well-built wood-frame home, perched at the corner of Pleasant Street and Savin Hill Avenue, was

framed by two massive elms. When it came to the large tracts of land he amassed in Dorchester and beyond, the preacher, politician and judge proved a staunch proponent of property owners' issues and rights.

Various historians would contend that Stoughton, deemed by contemporaries and Dorchester neighbors as often "hard, obstinate, narrow-minded…having a bull-dog stubbornness," did have two governing passions: his landholdings and Harvard. A biographer asserts, "[Stoughton was] apparently a loyal servant of the King—except when the interest of the Crown conflicted with his own interests as a landholder or the interests of Harvard College, of which he was one of the most generous native benefactors." He gave the staggering sum of £1,000 to his alma mater for a new dormitory. In his will, he bequeathed valuable land to "Harvard College at Cambridge, the place of my first public education (which nursery of good learning hath been of inestimable blessing to the Church and people of God in this wilderness, and may ever continue to be so, if the people continue in the favor of God)."

Stoughton was appointed lieutenant governor of the colony in 1692, and when Governor Sir William Phips sailed for England in 1694, Stoughton became Massachusetts's highest official and would govern, with the exception of May 1699 to July 1700, until his death. Still, he would leave his chief imprint in the colony's history not as a governor, but as a jurist in one of the colony's most controversial and infamous episodes—the Salem witch trials in 1692.

As the furor over "Satan's Shadow" in the settlement north of Boston swept across the colony in 1692, Stoughton stepped into the tragedy front and center as the chief justice of the Court of Oyer and Terminer that conducted the explosive trials. Several of his fellow citizens and later generations of historians would condemn Stoughton as the arch-villain of the trials. "His insistence on the admission of 'spectral evidence' [with little basis in reasonable proof] as well as by his overbearing attitude toward the accused, the witnesses, and the jury—was largely responsible for the tragic aspect they [the trials] assume," contends a historian whose view is shared by many scholars.

In his own day, the Dorchester judge's reputation did not suffer anywhere near as severely as after his death. "It is notable, however," writes one chronicler, "that his part in the witchcraft delusion did not damage him in the eyes of his contemporaries and that he died respected as one of the most eminent citizens of the colony."

Judge Samuel Sewall, who had also played a pivotal role in the execution of the convicted "witches," publicly recanted his decisions from the bench during the trials. Stoughton, however, refused to make a public apology, "saying that he had acted up to the enlightenment he had at the time [of the witch trials] although he had since been convinced that he had been in the wrong." In 1853, *Putnam's Magazine* claimed, "Chief Justice Stoughton, after the delusion was over, sent a note to the pulpit on Sunday desiring prayers for his pardon, if in any way he had sinned by his course in the trials; and as it was read

he stood up in his pew, showing by his quivering lip the strong feeling within."

Stoughton died in July 1701 and was laid to rest in Dorchester's Old Burying Ground. While historians would generally rate him as an able governor, the Salem witch trials and his own difficult personality would tarnish

him in the collective eyes of critics. Palfrey's *History of New England* brands Stoughton a "rich, atrabilious bachelor, one of those men to whom it seems to be a necessity of nature to favor oppressive and insolent pretensions, to resent every movement for freedom and humanity as an impertinence and affront." "Pudding-faced, sanctimonious, and unfeeling," harangued another writer. Perhaps the most fitting epitaph, one that captures the Dorchester jurist and politician as the quintessential man of his times, rings in the words of Reverend Samuel Willard as he delivered Stoughton's funeral sermon in July 1701. Justice William Stoughton, Willard said, died as "the last of the original Puritans."

A GREEN BASTION OF BRAHMIN TRADITION

In 1999, for a few giddy days, Brookline, Massachusetts, became the world capital of golf as the finest American and European players—along with their camp followers—arrived there for the Ryder Cup. The venue was Brookline's oasis of Brahmin tradition, the Country Club.

Founded in 1882, the Country Club was intended for riders, not Ryders. The site was the old Stock Farm on Clyde Street, and it featured bridle paths, polo fields, a steeplechase course and a horse-racing oval. For non-equestrians, there were a bowling alley and lawn tennis courts.

In 1893 came the golf course—and trouble. First there were the construction workers, who, a member huffed, were "shanty Irish" trooping all over Brookline. Then there were

the golfers. The club's equestrians complained that golf balls were whizzing across the riding paths, constituting "a menace to all." The golfers countered that the riders were harassing the flock of forty sheep imported to keep the fairways trimmed. During one angry encounter, a horseman accosting a golfer "temporarily took leave of his senses and cried, 'Damn,' within earshot of a lady." That earned him a six-month suspension from the grounds.

One of the club's most avid golfers, Arthur Hunnewell, soon learned that his fellow members were hard to impress. At an exhibition to christen the original six-hole course in front of "several dozen socialites," Hunnewell knocked his opening drive straight into the cup. However, as a witness to the hole in one later put it, "This great accomplishment was met with stunning indifference. After all, isn't hitting the ball in the hole the point of all this golf business in the first place?"

By the turn of the century, though, golf had carried the day. In 1899, the club purchased additional acreage for expansion. In 1903, the club had a complete tract of eighteen holes. The rout of the Country Club's cavalry, however, was not final until 1969, when the racecourse that had interrupted golfers on the first and eighteenth holes for sixty-six years was closed.

A "MASSACHUSETTS FLAG" OVER RICHMOND

Harvard-educated Paul J. Revere, a major in the Twentieth Massachusetts Infantry, was wounded and captured in 1861

and thrown into Richmond's notorious Libby Prison. It was there that he met Elizabeth Van Lew, one of the most remarkable women of the Civil War. Van Lew came from a leading Richmond family and used her social standing, her guile and her considerable fortune to gather intelligence vital to the Union cause. Always under Confederate suspicion, she managed to help Union prisoners by bringing them food, clothing and writing materials and smuggling letters to their families. Van Lew wrote encouraging letters to Major Revere's wife and two children and even helped him plot an unsuccessful escape.

Revere was paroled in 1862 and killed at Gettysburg in 1863. Van Lew continued with her espionage right up to the fall of Richmond. At that point, she finally revealed her true colors in a grand gesture that made her an outcast among her neighbors and friends. When General Grant's troops marched into the fallen Confederate capital on April 3, 1865, they were astounded to see a huge nine-foot-by-twenty-foot U.S. flag flapping from a window of Van Lew's mansion.

When he became president, Grant rewarded Van Lew with the job of postmaster general of Richmond. But under his successor, Rutherford B. Hayes, she was hounded from the post by Southern enemies and sank into poverty. That was when her kindness to Major Revere twenty years earlier bore fruit. Revere's children gave her money enough to live the rest of her life in comfort. When she died in 1890, they bought the flag she flew over Richmond and gave it to the Paul J. Revere Post 88 in Quincy. Now it hangs

proudly in the Quincy Historical Society in memory of the friendship between a gallant lady spy and the grandson of Paul Revere.

THE SAGE OF PITTSFIELD

Few remember Massachusetts Senator Henry Lauren Dawes, "The Sage of Pittsfield," a nineteenth-century political titan who wrote his era's landmark Indian relief bill some 122 years ago. Unfortunately, the Dawes Act heralded a 47-year nightmare for the people it was intended to protect.

Dawes seemed an unlikely crusader for the Indians. Born in Cummington, Massachusetts, in 1816, he served eighteen years in the U.S. House of Representatives and another eighteen years in the U.S. Senate, mostly protecting New England's agricultural, industrial and fishing interests. In 1880 he accepted the chairmanship of the Committee on Indian Affairs. Unlike his predecessors in the post, he was appalled by the government's treatment of the Western tribes. Dawes demanded, in the wry phrase of a colleague, that Americans "make the Indians feel at home in America."

Enacted on February 8, 1887, the Dawes Act guaranteed Indians American citizenship and broke up their reservations into farm-sized individual plots. In 1889, Dawes spearheaded the establishment of a national network of Indian schools.

The Dawes Act, laudable in its aims but misguided in its approach, unleashed a catastrophe. The senator's belief in the New England virtues of land ownership and self-sufficiency blurred his perceptions and confounded the tribes. Speculators swooped down and bought vast amounts of Indian land from its owners, who were unwilling and ill-suited to become the Christian farmers and small businessmen of Dawes's vision.

The carpetbagging was stopped by the Indian Reorganization Act of 1934, but by the time Dawes died in 1903, it was already apparent that his law had been a calamity. It was an ironic fate for the man of whom Edward Everett Hale had written: "While Dawes held the reins, nobody talked of dishonor in our dealings with the Indians."

"Such a Mighty Storm of Wind and Rain as None Living in These Parts...Ever Saw"

In August 1635, a hurricane blasted ashore across New England and not only pounded the fledgling communities of Puritan Boston and Dorchester but also, offshore, a ship carrying an ambitious young cleric named Richard Mather and his family to Boston. As the *James of Bristol* was buffeted by screeching winds and mountainous, foaming dark waves, Reverend Mather's chances of reaching shore ebbed by the minute.

The eye of the hurricane passed between Boston and Plymouth, where Pilgrim Governor William Bradford wrote:

> *Such a mighty storm of wind and rain as none living in these parts, either English or Indian ever saw…It blew down sundry houses and uncovered others…It blew down many hundred thousands of trees turning up the stronger by the roots and breaking the higher pine trees off in the middle.*

A twenty-foot tide surged into Boston and the low-lying tracts of Dorchester. Along "Rocky Mount" (Savin Hill in later days), terrified settlers huddled in their wood-frame homes and barns.

The storm's eye passed between Boston and Plymouth, and farther south, Narragansett Bay flooded, drowning seventeen Native Americans; countless trees were toppled throughout southern Massachusetts.

"The Great September Gale"

In September 1815, another memorable hurricane touched down in New England and left its devastating footprints. The "Great Gale" first hit Long Island, New York, and then swept into New England, blowing apart homes, unleashing massive floods that submerged a large tract of Providence and ripping through coastal Massachusetts.

Historian William Dana Orcutt wrote of the hurricane's literal impact upon the local landscape:

> *In 1815 there was a great gale which destroyed the arch of the bridge over the Neponset River. This arch was erected over the bridge at the dividing line of the towns* [Dorchester and Milton] *in 1798…The inscription on it, in letters of gold, read, "We unite in the defence of our country and its laws."*

Though sturdily constructed, the arch had proven no match for nature's wrath. Neither had Dorchester's venerable First Parish Meeting House. Orcutt recorded in the late nineteenth century, "The same gale caused such damage [to the meetinghouse] that it was finally demolished, and the present structure was erected to take its place."

MISERY AND MILESTONES: THE 1901 U.S. OPEN HAD THEM ALL

As the familiar "click" of club against "guttie" ball (made of gutta-percha, from then-Indonesia) pealed above Myopia in Hamilton, Massachusetts, on June 17, 1901, the sound heralded the imminent end of an era. That click also signaled the start of the U.S. Open's first playoff, between transplanted Scots Alex Smith and Willie Anderson. A dubious distinction awaited the winner—the champion would card the highest seventy-two-hole total in the Open's annals. Not one of the field's "cracks" (finest players) would break eighty.

Additionally, the 1901 Open featured player's mutters about the rock-hard fairways, bad lies, shifting winds and fast, tricky greens in a historical preview to the 1974 U.S. Open "Massacre" at Winged Foot, New York, and the 1999 British Open "Carnage" at Carnoustie, Scotland. If that was not enough to mark the 1901 Myopia Open as memorable, the event included a fit of temper by Anderson against the club's patrician members and complaints by a Brahmin socialite about the players' "working-class" dress and demeanor. In the landmark playoff, one player mounted a stirring comeback as the other wilted. Fittingly, a blown "gimme" putt on the final hole decided the outcome.

From virtually the moment that the entrants took their first practice swipes at Myopia, the mutters began. Redesigned to eighteen holes that wound up and down 6,130 yards, the tract's thin grass and greens, where gutta-percha balls skittered or raced past the cups and into shrubs or ditches, bedeviled the professionals from the start. British great J.H. Taylor, who was not at the 1901 Open, held the course record of seventy-eight, a number that no player would see in the upcoming contest.

Unlike the 1900 U.S. Open, which had featured Taylor and champion Harry Vardon, Myopia's second Open lacked those "big guns." But Anderson, who would capture four U.S. Opens, was about to burst into prominence, and professionals such as Willie Chisholm, Laurie Auchterlonie, Willie Smith, Alex Smith, Alex Findlay and "nearly all the crack professionals of the country" had gathered at Myopia to battle for the $200 winner's purse.

At 9:30 a.m. on June 14, beneath a bright sun, the pairings teed off into a swirling wind. The gusts and the hard fairways sent gutties skidding along the "Alps," the "Long Hole," the "Prairie," the "Valley," the "Paddock" and every other inch of the course into bushes, high grass, water and bunkers. Players' tempers swelled as well-struck balls still found trouble. Putts rocketed off the greens. Anderson, misreading three short putts, was seething by the end of his morning round, an eighty-four.

As Anderson and the other professionals gathered for lunch outside the stately clubhouse, a Myopia member informed them that they must eat in the kitchen. Anderson, muttering in his North Berwick, Scotland burr, began swinging his mashie (a club) faster and faster near the member until the Scotsman sent a sizeable patch of turf flying. The member fled into the clubhouse and then returned to say that a lunch tent would be raised for the players.

The afternoon round unfolded with a continuing litany of brutal bounces and frayed nerves. Typical of the course's punishments for errant shots were the ankle-deep swamp Anderson splashed out of and two boulders squeezing one of Willie Smith's drives. A *Boston Globe* reporter understated, "Many golfers complained of bad lies through the greens." At day's end, Anderson sat in third place with a 167, three in arrears of the leader, Alex Smith.

The players shivered in a frigid northeast wind raking Myopia beneath glowering gray clouds on Friday, June 15,

1901. No rain had fallen yet, so the course remained hard, but the greens had been watered and rolled, a fact that made Anderson and Smith "confident of bettering their scores from 8 to 10 points over yesterday's game." Their hopes proved wishful thinking.

Anderson, paired with Auchterlonie, who held second place at 166, was flocked by the tourney's largest gallery and struggled in the damp gusts. Eventually, Anderson began nailing long putts to scramble to an 83 despite "some rather poor golf." Alex Smith carded an 87.

In the afternoon round, Anderson shot a passable 81 in the face of shot-tossing gusts. Then, at 331 for seventy-two holes and the lead for the moment, he could only stand and wait for Smith to finish.

Smith strode to the eighteenth with a seventy-six—and a chance to break that elusive eighty barrier. More importantly, a three would beat Anderson for the championship. When Smith rifled his second shot some ten feet from the hole, he confronted a choice to go for broke on the fast and fickle green or to play two putts for a tie. He scrutinized the green, five hundred spectators pressing near him. Then he putted. "It's going in," said someone. But it stopped near the cup's rim.

Smith nudged it in for a four, finishing with the Open's best round, an eighty. Newspapers trumpeted the drama as the "Most Exciting Finish in History." For the first time, a U.S. Open was headed to a playoff. Smith and Anderson, however, would have to agonize until Monday—Myopia's members had the course for the weekend, some of them

dismayed by the professionals' "plebeian character." The *Boston Herald* reported:

> *Only three or four of the* [professional] *players appeared in knickerbockers. The "pros" don't go in much for fancy dress, and a disappointed young socialite who evidently anticipated seeing a rare display of red coats declared that so far as their garb was concerned, they might be "hired men."*

On June 17, 1901, the Anderson-Smith duel finally unwound. A spectator described it as "a long tale of mishap and disaster" concluded by a "a soul-stirring finish." Smith forged ahead with a seemingly insurmountable five-stroke lead by the thirteenth, benefiting from calm weather. On the fourteenth, Anderson, after a long series of topped drives and poor putts, turned to his friend and fellow golfer Alex Findlay and said, "I say, Alex, give me a cigarette, will you, and I'll win out this thing yet." Findlay complied. Coincidentally or not, Anderson surged, steadily whittling away at Smith's lead.

Smith's lead—now plagued by "toppers" and skittering putts—had dwindled to one as they launched their drives on the 335-yard eighteenth. With Anderson two-putting for a four and Smith trying to recover from his second shot, sprayed behind an embankment, the latter needed a five just to tie. Still, the putt for his five was short. Frazzled, Smith pushed a slow, faltering putt. "It was hard to believe one's eyes," the *Herald* recorded, "but the ball was still there,

a few inches away." Smith gaped and then slammed the ball toward the clubhouse with his putter.

The press acknowledged the excitement of the playoff's final five holes but concurred that the real "conqueror" was the treacherous Myopia course. According to the *Herald*, "Without belittling...the pluck of the players, the

performance of both…was more of a defeat for one than victory for the other." The *New York Times* blamed the wind and cold in large measure for the "disappointment" of the high scores.

The sharp click of Smith's putter launching his offending ball at the Myopia clubhouse proved the death knell for the gutta-percha ball at the U.S. Open. In the 1902 Open, many of the players switched to the Haskell Ball (1898), thin rubber strips threaded around a solid core and thinly cloaked with gutta-percha, because it flew farther, was forgiving and could be satisfactorily controlled. The Haskell's "feel" brought scores down at the 1902 Open, won by Auchterlonie with a seventy-two-hole total of 307—24 better than Anderson's and Smith's 331 at Myopia.

Still, given the gusty winds, hard surfaces, fast, sneaky greens, thin grass and daunting shrubbery and boulders at Myopia in 1901, even the Haskell ball might not have spared many players from misery.

A PARTY FOR THE AGES: FOURTH OF JULY 1855

On the Fourth of July 1855, a Massachusetts town threw a party—not just any party, but one of the largest Independence Day celebrations in the nation's annals to that point. Over two thousand locals gathered in a massive tent "erected on [Dorchester's] Meeting House Hill" for a community dinner, the precursor to the Fourth of July barbecues of later generations.

Dorchester's Fourth of July feast proved so big an event that the Boston newspapers, as well as others throughout the region, lauded the Meeting House Hill banquet as "the most prominent celebration of the day in this vicinity," an event "observed in a spirited and patriotic manner."

At dawn on that summer day in 1855, a cannon's roar rattled windows and rousted locals from bed. Few minded, however, as the cannon's peal and the din of church bells that followed signaled the "patriotic ceremonials of Independence morn." A local man recalled, "At the same time [dawn] the beautiful flag of our country was thrown to the breeze from a hundred different flag-staffs, and as it floated over and among [Dorchester's] delightful groves, it looked more beautiful than ever."

Perhaps the sight of that flag carried more significance that day than in many other Fourth of July celebrations, for the United States was lurching closer to the Civil War. In Dorchester, the 1855 gala would eclipse or equal similar gatherings throughout the nation.

About 8:00 a.m., people from Savin Hill to the Neponset River and all surrounding local points, as well as throngs of people from Boston and other cities and towns, headed for Meeting House Hill, some strolling on the streets, others riding horses or nudging carriages through the crowd. The tent atop the slope would hold some two thousand, but thousands more had come to see the "Grand Procession," which would wind along a parade route to a pavilion erected atop Webster Hill. There, an even larger tent than the one at Meeting House Hill had been raised, the Webster Hill canvas clotted with nearly five thousand spectators.

Marching or riding first through the crowded streets in the procession were the independent corps of cadets, who "turned out 57 guns," the Weymouth Brass Band and "invited guests in carriages."

A *Boston Daily Journal* reporter wrote:

> *Next came a party of "United Americans" in a carriage drawn by eight fine gray horses. The persons in the carriage were dressed in three-cornered hats and scarves. Next came a boat on wheels called the "Everett Barge." It was filled with a delegation of children from the Everett School, fifteen in number—all handsomely attired. Next came the Fire Department. The members were in uniform, and their [fire wagons] dressed with flags, flowers and evergreens.*

All along the parade route, flags and bunting adorned homes. Shortly after 11:00 a.m., the procession picked up the celebration's featured speaker, Edward Everett, "New England's gifted orator and statesman," at the house "in which he was born" at the corner of Pond and Cottage Streets.

The *Boston Daily Journal* related:

> *As the procession entered Webster Street, it was greeted by the school children of Dorchester, drawn up on each side of the road, dressed in neat attire…each school bearing a neat banner having on it the names of the school. The children greeted [the procession] with the most enthusiastic cheers.*

The parade halted at the Webster Hill pavilion about noon, the entire expanse of the hill and tent mobbed, "a very large portion of the audience being ladies." A program of patriotic music and speeches followed, and the highlight, listeners and the press concurred, was Everett's "able and eloquent oration, occupying two hours and twenty minutes, and which was listened to with the most earnest attention" and evoked "hearty applause."

As inspiring as Everett's speech was, the event that followed—"the Proceedings at the Dinner Table"—would linger in local memory as one of the era's finest community events and one that any American city would have been hard-pressed to match. At least two thousand people streamed from the pavilion to the Meeting House Hill banquet tent and sat down at long tables "profusely ornamented with beautiful bouquets from the splendid gardens in Dorchester" and groaning beneath platters of food and pitchers of spirits and nonalcoholic drinks alike. The horde of diners tore into "the sumptuous dinner… provided by Mrs. J.B. Smith." Second and third helpings of Mrs. Smith's mouthwatering repast, toast after toast to the town and to the nation, laughter, song and an all-encompassing sense of community pride—the sights and sounds atop Meeting House Hill on the Fourth of July 1855 composed an unforgettable day for all who entered the tent. As one satisfied reveler remembered, "[Massachusetts] is proud today."

FIRST IMPRESSIONS:
IN 1848, A YOUNG CONGRESSMAN NAMED LINCOLN
CAME TO MASSACHUSETTS

On September 16, 1848, a tall, angular congressman with dense, slightly unkempt dark hair strode behind the podium of Richmond Hall in Dorchester. He had come to campaign for the Whig Party's presidential candidate, General Zachary Taylor, hero of the Mexican-American War. As the congressman began to speak in his folksy Illinois manner, the residents crowding the hall took the measure of that speaker, thirty-nine-year-old Abraham Lincoln.

Lincoln, elected to the U.S. House of Representatives in 1846, had been selected at the Whigs' national convention, in June 1848, to stump for Taylor in Maryland, Massachusetts and Illinois. On September 12, he had shown up at Worcester, Massachusetts, with little or no advance notice to address the state's Whigs on the burning issue of slavery. To prepare for his campaign swing through Massachusetts, he asked William Schouler, the editor of the *Boston Atlas*, to provide him an "undisguised opinion as to what New England generally, and Massachusetts particularly will do [in the upcoming presidential election."

On September 16, 1848, local Whigs streamed into Richmond Hall, few having heard much about the visitor from Illinois. Lincoln, fully aware of the strong abolitionist stand of many in the audience, opened his speech with an assurance "that the people of Illinois agreed entirely with the people of Massachusetts on this subject." Injecting what

he hoped was a bit of humor, he cracked that the difference was that his home state "did not keep so constantly thinking about it" as did people in Massachusetts. The jest fell flat, and he shrugged and launched into the heart of his speech, offering that "slavery was an evil, but that we were not responsible for it and cannot affect it in the States of this Union where we do not live." He strongly cited his opposition—and Taylor's—to any extension of slavery to new U.S. territories, including those that the nation had seized from Mexico.

Lincoln had actually caused a stir in early 1848 by haranguing President James K. Polk for his conduct of the conflict with Mexico and had presented Congress with several resolutions demanding that Polk explain his wartime decisions. On January 22, 1848, the freshman congressman stood in the speaker's well of the House and denounced the prosecution of the war.

His opposition mirrored that of the majority of Massachusetts's voters and made him a logical, if largely unfamiliar, choice to line up the state's Whigs to get behind Taylor—ironically, perhaps, the hero of the Mexican-American War's pivotal Battle of Buena Vista in 1847.

At Richmond Hall, Lincoln's physical appearance and mannerisms caught the audience's attention as much as his oratory. Towering above the podium, he kept "leaning himself up against the wall…and talking in the plainest manner, and in the most indifferent tone, yet gradually fixing his footing, and getting command of his limbs, loosening his tongue, and firing up his thoughts,

until he had got entire possession of himself and of his audience."

Local listeners were divided over Lincoln's style. He intrigued some in Richmond Hall with his running patter of "argument and anecdote, wit and wisdom, hymns and prophecies, platforms and syllogisms"; however, his homespun Midwestern approach fell flat with other Whigs dismayed by "his awkward gesticulations, the ludicrous management of his voice, and the comical expression of his countenance."

One Massachusetts Whig who liked Lincoln's delivery complained nonetheless: "It was a pretty sound, but not a tasteful speech."

In local newspapers, reactions to the Illinois congressman's words ran along party lines. The *Boston Daily Advertiser*, a Whig paper, lauded, "It was one of the best speeches ever heard [in Massachusetts]." In the *Boston Herald*, Lincoln earned plaudits as "a tremendous voice for Taylor."

Democratic-leaning newspapers either ignored Lincoln's speech or assailed it. "Absolutely nauseous," stated the *Norfolk Democrat*. Equally harsh was the *Roxbury Gazette*'s assessment: "A melancholy display."

In the opinion of another local editorial writer, Lincoln's oratory was "rather witty, though truth and reason and argument were treated as out of the question, as unnecessary and not to be expected."

When Whigs departed Richmond Hall on September 16, 1848, few, even those who had enjoyed his speech, would have envisioned Lincoln as possessing presidential timbre.

Lincoln, however, would look back fondly to his days on the campaign trail of 1848. For the Illinois politician, Taylor's election to the White House vindicated Lincoln's earnest work on the campaign trail for "Old Rough and Ready," as Taylor had been fondly dubbed by his troops in Mexico.

Lincoln recalled, "I went with hayseed in my hair [to Massachusetts] to learn deportment in the most cultivated State in the Union."

Some thirteen years later, the Illinois congressman, whose speech at Richmond Hall evoked sharply delineated opinions among Massachusetts's voters, was elected to the same high office that he had helped Taylor win. Slavery, the issue that echoed throughout Lincoln's speech in 1848, had helped ignite the Civil War that Lincoln now confronted, and when the voice that had left many in the region unimpressed appealed for volunteers to fight the Confederacy, tens of thousands of Massachusetts men heard and answered the call in the ranks of the Union army.

A LITERARY LIONESS AND A WHIFF OF SCANDAL: SARAH WENTWORTH APTHORP MORTON PENNED QUITE A REPUTATION

In the "sky parlor" of a mansion in 1789, a quill's scratch broke the silence. A beautiful woman was composing verse that would earn her acclaim as one of the early republic's foremost female voices of letters. So famed did the name of Sarah Wentworth Apthorp Morton become that she was

credited with writing the earliest American novel, *The Power of Sympathy*, and was said to have done so in the Dorchester mansion known as the Taylor Place.

In several early histories of the town, chroniclers boasted that the nation's first bonafide novelist had lived and worked in the mansion with the view of Howard Avenue. What better proof, locals, as well as historians across the nation, noted, than the fact that in the landmark book, "she recorded, skillfully disguised in an intricate plot, the seduction and death of her favorite sister."

There was one problem. While Morton did craft verse in the sky parlor of that home and while her sister did indeed meet that sad fate, Sarah Morton had not written *The Power of Sympathy*. The likely author, a not particularly well-known poet, playwright and essayist named William Hill Brown, lived nearby. Although Sarah Morton did not write the milestone story, she did launch much of a reputation as one of the nation's first ladies of literature from her sunny nook at Taylor Place.

Sarah Wentworth Apthorp was born in Boston into a life of colonial privilege in 1759, the daughter of James and Sarah (Wentworth) Apthorp. Both parents hailed from affluent mercantile families, and Sarah was baptized at King's Chapel in Boston on August 29, 1759.

Sarah was raised in Boston and Braintree, and the pretty young girl soon displayed so precocious an intelligence that her parents, unlike so many of the era's people who believed that females needed only a basic education, afforded Sarah

the best schooling and schoolmasters locally available. A voracious reader, she showed a genuine flair and passion for writing, especially verse.

Along with her unusual education, Sarah Wentworth Apthorp was schooled in the social graces and possessed a large measure of charm. Her family associated with the foremost families of Massachusetts and was friends with John and Abigail Adams and the rest of the region's movers and shakers. With Sarah's beauty, intelligence and grace, she had the proverbial pick of affluent and eligible young men. The suitor who won out was a brilliant Boston lawyer on the rise in political and social circles. His name was Perez Morton, an ardent Patriot who had won acclaim for the eulogy that he had delivered at the funeral services of Dr. Joseph Warren, one of the Rebel heroes slain at the Battle of Bunker Hill.

On February 24, 1781, Sarah Wentworth Apthorp became Mrs. Perez Morton, and, in the ensuing years, she gave birth to five children and began publishing poetry in the leading journals and magazines of her day. Most of the time, she wrote under the pseudonym "Philenia," frequently contributing "her moralizing or eulogistic lyrics" to *Massachusetts Magazine*. In 1790, her first book of poems, *The Virtues of Nature, an Indian Tale*, "an idealized narrative on the 'noble savage' theme…in couplets," was published. The work was praised in both America and Britain.

Sometime between the late 1780s and 1790s, the Mortons moved from their State Street mansion to a splendid home at the junction of Dudley and Howard

Streets in Dorchester. Various accounts of Sarah Morton's life contend that she wrote *The Power of Sympathy* there. What is inarguable is that in the Taylor Place, the Mortons threw glittering soirées and dinners and that Sarah Morton composed some of her most highly acclaimed poetry in her sky parlor.

In the late nineteenth century, William Dana Orcutt described the mansion as a fitting site to inspire any author or poet:

> *The grand old house is still familiarly remembered by a large number of Dorchester's residents, but although a portion of its history is generally known, few realize to what varied events, joyful and sorrowful, gay and pathetic, the sturdy old walls had so long stood silent witnesses. Here the gallants of the last century led the fair maidens in courtly dance…here the literary, social, and political leaders exchanged their politest courtesies, and discussed subjects of the deepest importance to the nation.*

Orcutt wrote those lines about Sarah Morton's years in the area. He also referred to a scandal that had evolved at the Taylor Place. That tragedy, which many people would believe drove Sarah Morton to write *The Power of Sympathy*, literally hit the poetess where she lived. According to later scholars, Morton's husband, Perez, may have had an affair with her sister, and in the accompanying scandal, Sarah's sister killed herself.

In Orcutt's treatment of the affair, he writes, "It was in this room [the Taylor house's sky parlor] that Sarah Wentworth Apthorp, better known to the world as Mrs. Perez Morton, composed the first American novel, *The Power of Sympathy*," in which she recorded her sister's plight and death.

For over a century, locals and people throughout America believed that Sarah Morton had written *The Power of Sympathy*, a belief buttressed by "the similarity of the book's plot to a scandalous tragedy that had occurred in Morton's own life: her husband's affair with her sister, followed by her sister's suicide."

In 1894, literary scholars attributed authorship of the book—written "anonymously"—to the Mortons' neighbor William Hill Brown, who may well have witnessed "the seduction" firsthand. Since Perez Morton was one of the most powerful men in Massachusetts, Brown might well have feared letting the world know that he had written the novel, whose purpose, the author asserted, was "to expose the dangerous Consequences of Seduction."

The "seduction scandal" notwithstanding, Sarah Wentworth Apthorp Morton continued to write and publish well-received verse. On October 14, 1835, her husband Perez died, and the poetess lived for nearly a decade longer. She died at the age of eighty-six on May 14, 1846, "having outlived her children and all of her near relatives."

In the late 1800s, the Mortons' former mansion was torn down. Orcutt decried the act as "one of the most pathetic of the recent demolitions." The sky parlor where Sarah Wentworth Apthorp Morton had commiserated with her muse was gone forever.

"THE FAIRER SEX?":
BAY STATE BUCCANEER RACHEL WALL

Rachel started out innocently enough, until she married George Wall, a fisherman. He also had another profession —privateer. After they married, Rachel took a position as a maid in the house of a prosperous Beacon Hill family. Her husband, meanwhile, joined a gang of pirates, and whether he sweet-talked his new bride into joining him on the high seas or whether her own thirst for excitement led her aboard a privateer, she soon took up the pirate's trade in 1781.

The Walls and their companions sneaked onto a ship in Essex, Massachusetts, and slid out of the anchorage and into open waters, headed for the Isles of Shoals off New Hampshire. Once they steered their stolen vessel into those waters, they waited and scanned for sails on the horizon.

Reports soon reached Boston of a pirate ship preying upon vessels to the north. The pirates would hoist a distress flag to coax their unwitting quarry to approach alongside. Then the pirates—including Rachel—would pour across the gunwales of the other ship, murder everyone onboard, take their cash, jewelry and other valuables, toss the bodies into the waves and carry off the cargo.

Before the authorities in Boston could dispatch ships to hunt down the buccaneers, nature raised a savage hand against them in the form of a gale. The winds snapped the pirate ship's mainmast and dragged it overboard into the storm-tossed waves. Rachel could only watch as her husband thrashed in and vanished beneath the frothing

sea. The same waves soon dragged down the ship, but Rachel and several other pirates somehow managed to hang on to debris, tread water and remain afloat for several days.

A merchantman bound for New York found the survivors and plucked them to safety from the waves. Since the

buccaneers had murdered all their victims, no one suspected that Rachel and her companions were anything other than victims of a shipwreck.

Rachel went back to Boston, where her former employers rehired her. By day, she performed all of her household tasks. At night, she slipped from the Beacon Hill house and prowled the waterfront. She sneaked onto anchored ships and stole valuables from captains' cabins, often looting them as the men slept within scant inches of her. She would boast of one such raid, "I spied a silver watch hanging over the captain's head, which I pocketed."

As rumors drifted from Essex and elsewhere of a pirate crew that had featured a woman in its midst, authorities began to wonder about Rachel soon after she was arrested for robbing a Boston woman. Rachel professed her innocence of the crime, but at some point—the circumstances remain murky—Rachel admitted that she had been one of the Essex pirates but denied any hand in the murder of their victims at sea. As the Massachusetts General Court dug deeper into her story and pieced together the toll she and her fellow buccaneers had exacted from their prey, the authorities estimated that from 1781 to 1782, the seafaring gang out of Essex had seized and sunk twelve ships, had murdered at least twenty-four sailors and had carried away some $6,000—a huge sum for the era—in loot. The loot had perished with George Wall in the gale.

Rachel Wall stood trial for piracy, which carried a death sentence upon conviction. She was found guilty and uttered her final words as the noose was affixed around

her neck in Boston: "Into the hands of the Almighty God I commit my soul, relying on his mercy…and die an unworthy member of the Presbyterian Church, in the 29th year of my age."

THE QUIXOTIC CAPTAIN QUELCH

Like buccaneer Rachel Wall, John Quelch, born in 1666, had a short-lived but fiery tenure on the high seas. Quelch holds a unique niche in the annals of piracy. He had the misfortune of standing as the first colonist tried outside England under admiralty law that allowed trial without a jury, the measure enacted to combat colonial courts' inefficiency in bringing pirates to justice.

Quelch's seagoing career began legally enough in July 1703, when he signed on as a lieutenant to Captain Daniel Plowman of the warship *Charles*. Plowman and his crew had been granted a privateering license by Massachusetts Bay Colony Governor Joseph Dudley to seek and plunder French and Spanish ships sailing to and from the coast of Newfoundland and Arcadia.

From the start, Quelch had another mission in mind. Moored in Marblehead, Massachusetts, the *Charles* was seized by mutineers led by Quartermaster Anthony Holding. They imprisoned Plowman in his cabin and elected Quelch their new captain. He steered the ship south—with piracy as his mission. Plowman was tossed overboard when the ship reached open waters. Whether he was already dead would never be established.

Quelch and his gang sailed to the coast of Brazil and attacked and looted nine Portuguese ships, even though England and Portugal were not at war. Soon the *Charles*'s hold bulged with gold coins, gold dust, sugar, furs and other valuables. Historians would place the treasure-trove's value at over £10,000 sterling—many millions by today's standards. A legend that lingers to this day relates that before the crew returned to Marblehead and scattered with hefty cuts of the loot, the pirates buried a large gold stash on Star Island, off New Hampshire. In the 1800s, several Portuguese gold coins were discovered in a stone wall on the island.

The *Charles* returned to Marblehead ten months later and the crewmen dispersed with part of their plunder. Quelch was tossed in jail within a week of his return to Boston. Not only had he led raids upon a friendly nation, but he had also done so as England's Queen Anne and the King of Portugal signed a pact of friendship. Quickly soldiers rounded up his crew and dragged them to Boston.

The day of reckoning for Captain Quelch and his crew arrived on June 30, 1704. They had been sentenced to death without a jury under the new admiralty laws. Flanked by heavily armed soldiers, the pirates were marched to Scarlet's Wharf. The grim procession filed behind two ministers, and a local official carried a gleaming silver oar that was the emblem of Britain's Lord High Admiral.

A massive gallows awaited the doomed men at Scarlet's Wharf. In front of a dense throng of spectators, one of the ministers delivered a long and fiery sermon. All of the pirates professed repentance except one—John Quelch. He

stepped to the front of the gallows, removed his hat, bowed in a courtly manner to the crowd and delivered a "warning" about how unethically and unfairly the government had behaved in regard to privateering: "They should take care how they brought Money into New England to be Hanged for it."

Moments later Quelch and his crew were hanged. Soldiers cut down the dangling bodies and buried them "in between the tide marks."

Although never proven, a story would persist that Quelch designed the notorious Jolly Roger flag. His banner reportedly displayed "in the middle of it an

Anatomy with an Hourglass in one hand, a dart in the Heart with three drops of Blood proceeding from it in the other."

HANNAH'S CRUSADE

July 18, 1856, is an important date in the history of Rockport. On that summer morning two hundred wives, mothers, daughters and their assorted supporters gathered in Dock Square to take part in an event that would have repercussions to this very day.

Brandishing hatchets and led by Hannah Jumper, they began their raid. In the words of Ebenezer Pool, an eyewitness, "On finding any keg, jug, or cask having spirituous liquor in it...with their hatches broke or otherways destroyed it."

Hannah Jumper left her family's farm in Joppa and came to Rockport in 1812, a tall, redheaded, thirty-one-year-old seamstress. Her talent with a needle and thread, along with her abilities to grow herbs and make medicinal brews from them, helped her to build a pleasant life in the small fishing community. Thus established, Hannah began to form lasting friendships with many of the women who would later join her in the rebellion against "demon rum."

Although Rockport was a fishing community, the weather only permitted this activity for nine months of the year. Instead of finding other employment during their enforced

three-month "vacation," many local men went on a ninety-day binge.

Rockport's women, with household bills piling up as fast as their men's empty liquor bottles, agonized over the

unbridled drinking. Hannah Jumper not only shared their feelings and their concerns, but also started to chastise drunken men to their faces.

In 1856, as nationwide the temperance movement and women's suffrage began to unfold, the early rumblings of women's rights being heard, the women held clandestine meetings and plotted a raid. The women revealed their plan to three men—all teetotalers.

The big day dawned early in the morning of July 8, 1856. The seventy-five-year-old Hannah and four other ringleaders gathered scores of Rockport's women. They hid small hatchets under their petticoats and shawls and headed out to their targets—the homes of distillers and brewers and several stores that carried liquor. On the previous night, Jumper and several of her supporters had sneaked around town and had marked the offenders' doors with small white crosses.

The "temperance mob" swarmed to each site, stormed inside and swung their hatchets against every cask and container they could find. As their blades thudded against wood and gashed open barrels, the reek of harsh, homebrewed whiskey and other spirits filled the seaside air. The curses of stunned men erupted from Bearskin Neck to Pigeon Cove. The raiders ignored the din and swept from target to target, their clothes reeking with the smell of spattered spirits, their hatchets poised to smash open the next cask.

For some five hours, Jumper and her troops swept through Rockport. Finally the raids ended when the "marauders" decided to go home and prepare supper for their families.

Not all of the locals accepted Jumper's crusade to stamp out "demon rum." Jim Brown, who had seen his stash gushing onto the ground courtesy of the Jumper gang, took the temperance women to court several times. Each time, he lost. His counterattack ended when he was forced to pay the costs of the defendants' legal fees—$346.35, a steep pricetag for the era.

Hannah Jumper's victory lasted until 2005. In that year, Rockport's voters narrowly overturned the town's "dry" status. Still, Jim Brown might have considered the measure a "half-empty" approach, as the voters only approved liquor in local restaurants—no bars and no package stores.

Visit us at
www.historypress.net